The Secret of
WATERCOLOUR
Essential Skills For Successful Painting

The Secret of
WATERCOLOUR

Essential Skills For Successful Painting

JAMES FLETCHER-WATSON

B T BATSFORD LTD, LONDON

B T Batsford Ltd, London

First published 1997

© James Fletcher-Watson, 1997

ISBN 0 7134 7959 0

Published by

B T Batsford Ltd

583 Fulham Road

London SW6 5BY

Printed in Singapore

CONTENTS

Dedicated to my dear wife,
Gill, whose unfailing help and encouragement is
a tremendous support in all my endeavours.

INTRODUCTION

I am delighted to have been asked to write another book on painting with watercolours, because although I have already written four books on the subject, I am continually meeting people who have only just started to paint landscapes in watercolour and who badly need practical guidance. This new book, *The Secret of Watercolour*, is therefore written primarily with beginners in mind as well as more advanced painters who may wish to brush up on their techniques.

Some people feel that watercolour is very difficult, but it is often the case that they have not given enough thought to the subject before they start. Painting is a constant challenge to produce the perfect picture, and studying composition, as described in Chapter 2, is the basis of all good landscapes. The great masters like Turner, Cotman, De Wint and Bonington showed us the way and it is right that we should follow in their footsteps, not copying but receiving inspiration from them. Constable was another genius and, although essentially an oil painter, he was one of the greatest interpreters of the landscape with his simplified treatment of trees, skies, water reflections and distant views.

My aim is to carry on the torch, encouraging today's painters to express the beauty of the landscape simply and effectively. I hope this book will inspire many people to paint with enthusiasm and achieve successful works in watercolour. It is a very lovely medium to use especially if you can master the technique of creating transparent washes, one of the hallmarks of a good watercolour.

CHAPTER 1

EQUIPMENT

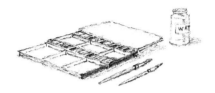

In this chapter I will outline the various watercolour painting materials it is advisable to have. Whether you are an outdoor landscape painter, an indoor still life painter, or someone unable to paint out of doors because of ill health, you will still require certain basic items such as paints, a selection of brushes, some pencils and paper. If you are a newcomer to painting, it is very easy to go into an art supply shop and buy the wrong type of equipment or perhaps some unnecessarily expensive items that you do not really require. Even worse, a well-meaning aunt may give you a present of a large paintbox containing entirely the wrong selection of colours!

There is also the question of where best to do your painting. A lot of people only have time to paint in the evenings or at weekends and the kitchen table might be the only suitable place for painting. I found this problem when I first started out and I know what a nuisance it is having to clear up after each painting session.

Of course ideally you should have a room you can devote to painting which you can use as a studio. **Figure 1**

1 The studio

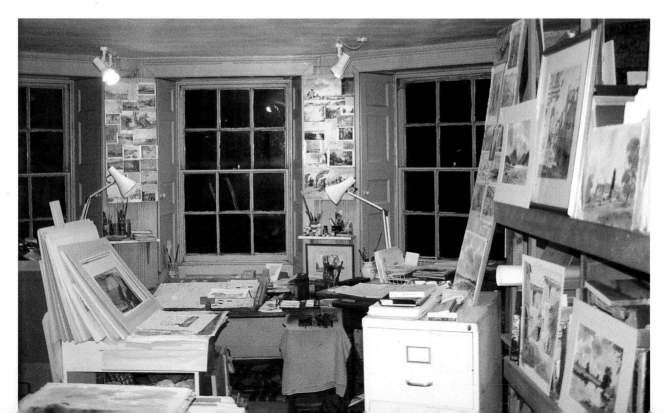

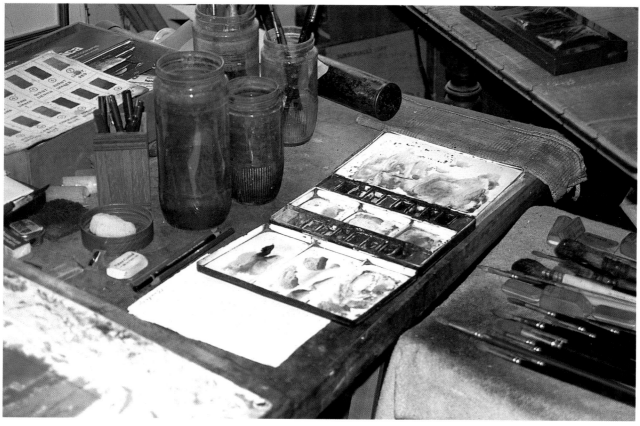

2 My paint box

shows a general view of my studio with three large windows facing north. This is preferable as you do not want sunlight and shadows lying across your painting board or easel. You will notice two anglepoise lamps which are fitted with daylight bulbs. These, combined with the four ceiling lights, which are not daylight, give me an extremely good artificial light to work under. It is a great advantage to be able to continue painting after dark.

Figure 2 shows my paintbox, brushes and water jars on the right side of my work-table, always ready for immediate use. Before I actually start painting, my first act is to soften up all the watercolours in their pans with a stiff oil painter's brush held under the hot tap. This is a useful tip as colours have a nasty habit of going hard when not used for a day or two, and it is very bad for good sable brushes to work on a hard colour that has not been softened.

Figure 3 shows me at work at my large board in the studio window. This board is resting at a slight slope and is an ideal height for painting when sitting on a chair.

The view from the window takes in a bit of garden and plenty of trees and fields with Cotswold hills in the distance, and a wide expanse of sky. Although I know the view well, I still find it to be a continuous inspiration, reflecting the changing colours of spring, summer, autumn and winter, and especially useful for observing changing skyscapes. When painting in the studio I often find that the view of the sky from the window is an ideal subject.

3 At work in the studio

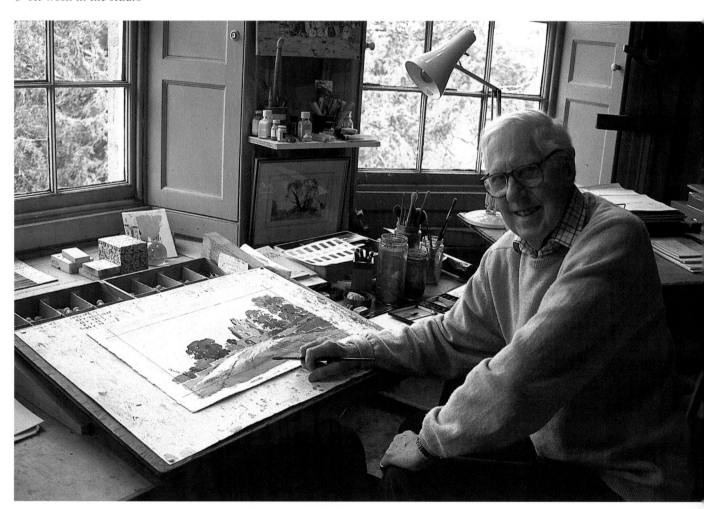

As regards the actual range of materials the watercolour painter needs, I have dealt with this at some length in my previous books, but I would like to mention them once again briefly here.

Pencils

HB, B and 2B are sufficient for drawing a subject that is to become a watercolour picture, while 4B, 5B and 6B are useful for doing pencil drawings in a sketchbook to be referred to at a later date when making a watercolour. Throughout the book you will see various examples of such sketches.

Eraser

Good makes are the Factis or Faber-Castell pencil erasers which stay flexible longer than most types and are available in art shops.

Brushes

Numbers 1, 3, 5, 7 and 10 will give you all the brushes you require for any size of picture. Sable brushes are the best but these are very expensive and the synthetic brushes made by most art firms are quite adequate. I always like to have a No. 8 squirrel mop brush at hand as well, which is useful for doing a loose type of watercolour sketch or for painting skies or trees.

4 Preparatory sketch showing use of 4B and 6B pencils

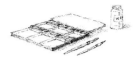

Paints

I tend to use tubes of colour to replenish my pans as the colour gets used up. My list of 14 colours is given below.

1. Cadmium Lemon
2. Cadmium Yellow
3. Raw Sienna
4. Raw Umber
5. Burnt Sienna
6. Burnt Umber
7. Light Red
8. Indian Red
9. Rose Madder
10. Cobalt Blue
11. Cerulean Blue
12. French Ultramarine
13. Winsor Blue
14. Payne's Gray

Figure 5 (opposite) shows a colour chart of this selection.

There are several brands of watercolour paint and you can take your choice. I have always preferred Winsor & Newton colours. This company has recently introduced a number of new colours, but the colours mentioned in this book remain part of its standard list.

Paint Box

I like using the old style of box which holds individual pans and has ample mixing palettes in the folding lid. Various sizes are available but I find the bigger the better (see **Figure 2**). (Note – 'The Fletcher-Watson' large paint box can now be obtained from Craig Young, 14 Park Crescent, Cuddington, Northwich, Cheshire CW8 2TY.)

Paper

A great many types are sold in all good art shops. My favourite makes are Winsor & Newton watercolour paper, Whatman paper, Saunders-Waterford, and Bockingford papers. I would recommend the latter for a beginner as it is the least expensive and can be obtained in single large sheets or in book form. All the papers mentioned here are made in different weights (thicknesses) and have different textures ('Rough' or 'NOT' i.e., smooth). You must experiment yourself and discover which you like best. I use all the above depending on the subject and effect I am after.

Sketchbooks

Daler books of cartridge paper are the ones I like best and are ideal for lead pencil sketching. They come in all sizes from very small to quite large.

Chair or Stool

I find a chair or stool ideal for outdoor painting. Many makes are available – I prefer a comfortable one with a back as I will often work in this way for several hours at a time. I also like a low chair so that I can reach my paints on the ground by my side.

Drawing Board

A piece of very stiff cardboard is good for clipping your paper to with large paper clips. This is lighter than a wooden board and easier to carry – quite a consideration when you are loaded up with your outdoor sketching gear!

Easel

There are many types of easel on the market and it is important to select one that is not too heavy to carry when it is folded. It is a very personal choice and can be quite an expensive investment so choose carefully. I tend not to use my easel very often.

Water

A large glass or plastic jar with a watertight screw top is ideal as a container for water.

Additional Items

A small sponge is used for cleaning your palette or wiping out paint on your picture. A brush case for protecting your brushes is also useful. Mine is a tube with a removable top at the open end. Blotting paper is important for emergencies during painting, while you will find a penknife very handy for sharpening pencils and for scratching out during the painting process. Finally, a canvas carrying bag for holding all your equipment is helpful.

1 CADMIUM LEMON

8 INDIAN RED

2 CADMIUM YELLOW

9 ROSE MADDER

3 RAW SIENNA

10 COBALT BLUE

4 RAW UMBER

11 CERULEAN BLUE

5 BURNT SIENNA

12 FRENCH ULTRAMARINE

6 BURNT UMBER

13 WINSOR BLUE

7 LIGHT RED

14 PAYNES GRAY

5 Colour chart

CHAPTER 2
COMPOSITION

I am starting off this chapter with composition because it is the first thing you should consider when choosing a landscape, townscape or even a still life subject. My motto is always – if a subject will not make a good composition, then don't paint it!

Let us now take a look at **Figure 6**, *Seathwaite, Cumbria*. This picture shows a simple and satisfactory composition of a mountain scene in the Lake District with a small white farmhouse as the centre of interest.

6 *Seathwaite, Cumbria*. 324 x 476mm (12 ¾ x 18 ¾in)

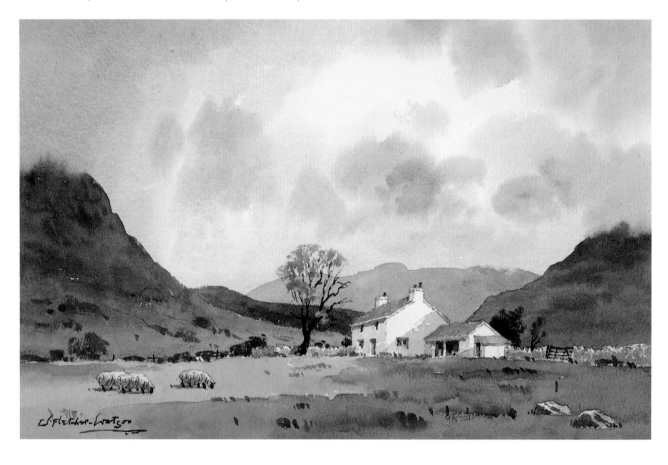

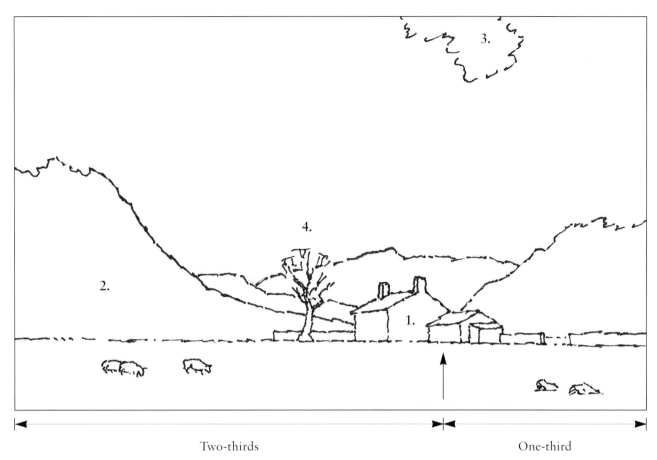

Two-thirds One-third

6a Compositional sketch

The diagram in **Figure 6a** shows you the main points I considered before painting the picture. The farmhouse[1] itself could have been in any position but I chose to have it just over one-third from the right side. The high mountain[2] on the left acted as a counter-balance to the farmhouse and was a strong feature because of its height and strength of tone. When planning the picture I purposely arranged the main patch of blue sky[3], to be in the top right position to give a further counter-balance of less strength but still of importance. You always have the freedom to adjust a cloudy sky to suit your purpose, rather than slavishly copying it.

Another dominant feature is the tree[4]. This is just to the left of centre and gives a useful vertical feature, contrasting well with the horizontal and sloping lines of the fields and hills.

Looking in more detail at **Figure 6**, other elements of the composition are the three sheep on the left and the two rocks in the right foreground. Neither of these actually featured in the picture when I painted it on the spot, but there were rocks and sheep visible elsewhere in the landscape. Artist's licence plays a part in landscape painting and it may be used, within reason.

Note the distant mountains which are painted blue-grey. They are a tremendous help in giving the picture the third dimension of distance. Finally the thin stretch of low hill seen in the centre and going behind and to the left of the house is of great importance. It has a very dark cloud shadow on it which gives punctuation to the whole picture. Also the foreground cloud shadow on the grass helps to give depth and perspective to the overall composition.

Figure 7, *Boadilla, northern Spain*, shows a delightful small village with a large church which my wife and I came across during a recent painting trip. This is rather a different example of composition. The first thing you notice is the intense brightness of light compared with the last picture of the Lake District. The hot Spanish sun was glaring down on the scene causing strong shadows to be cast on the buildings and ground.

7 *Boadilla, northern Spain.* 140 x 235mm (5 ½ x 9 ¼in)

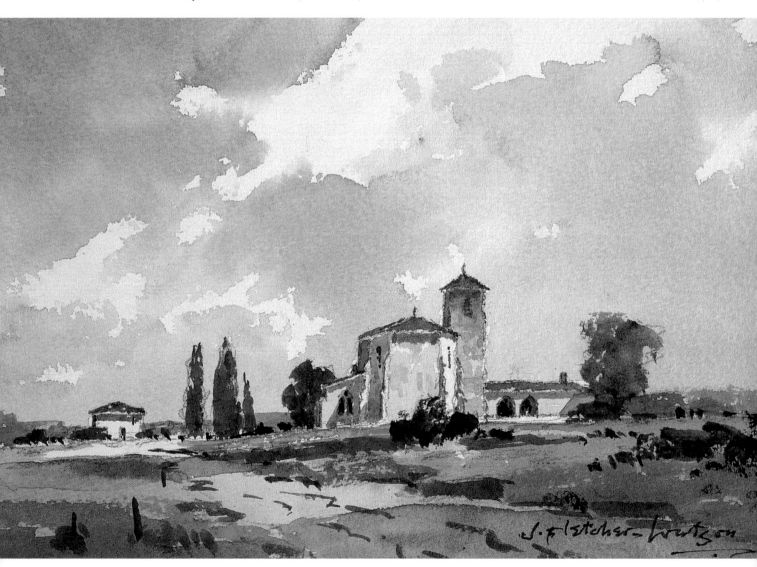

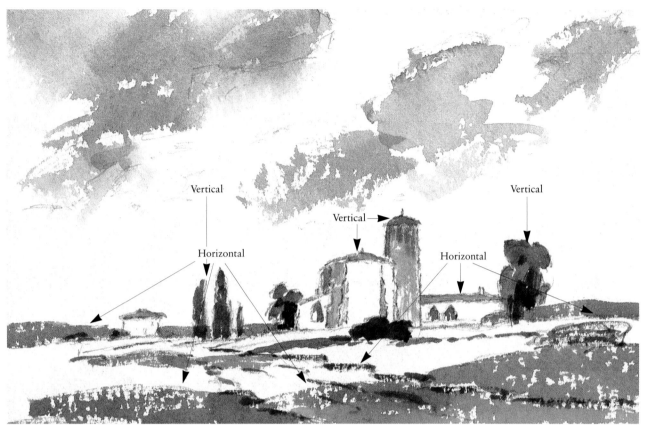

Vertical

Vertical

Vertical

Horizontal

Horizontal

8 Compositional sketch

If you look now at **Figure 8**, you will see I have shown in a diagrammatic sketch the striking *vertical* forms which contrast well with the equally pronounced *horizontal* lines.

The main *verticals* are the body of the church and the tower, the two cypress trees to the left and the large tree on the right. The horizontals are the distant line of blue hills running the full width of the picture, the cloister building on the right side of the church, the various cloud shadows lying across the landscape, and the edges of the road which are almost *horizontal* and carry the eye into the picture, also giving a useful perspective. The sky echoes the perspective of the road with sweeping grey and white clouds and some strong patches of blue.

Tone values are an important part of composition and here we have the strong dark green of the cypress trees, the tree behind the left-hand wing of the church and the low shrubs immediately in front of the church. These dark items help to intensify the sunlight and generally give a crisp quality to the composition.

For a mainly architectural subject I have chosen *San Gimignano, Tuscany*. The scene in **Figure 9** caught my eye immediately. The tall, vertical, stone houses on the right made a wonderful foil to the small horizontal cottage in the central position. The tower in the background gave a useful vertical feature, and the tree down the hill to the left made an invaluable stop-gap.

The white stone arch formed a focal point, and the second arch seen in the distance added depth to the subject which is exactly what was needed. The walking figures gave a little animation which always helps an architectural subject.

The stone walls were a delightful ochre colour consisting of various yellows and reds, and the roof tiles were the usual rich brown-red Roman tiles which are so typical of Italy. The dull green tree and window shutters added pleasing colouring, and a pink pullover worn by a woman in the foreground gave a touch of bright colour. A bright red rug hanging out of a window also helped the general composition.

Note the shape of the sky seen above and beyond the buildings and trees; it helps a picture enormously to have an interesting skyline shape.

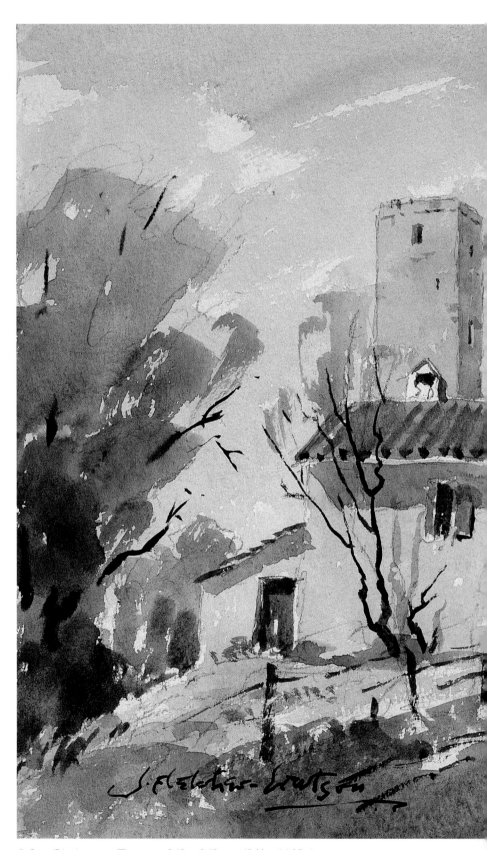

9 *San Gimignano, Tuscany*. 242 x 369mm (9 ½ x 14 ½in)

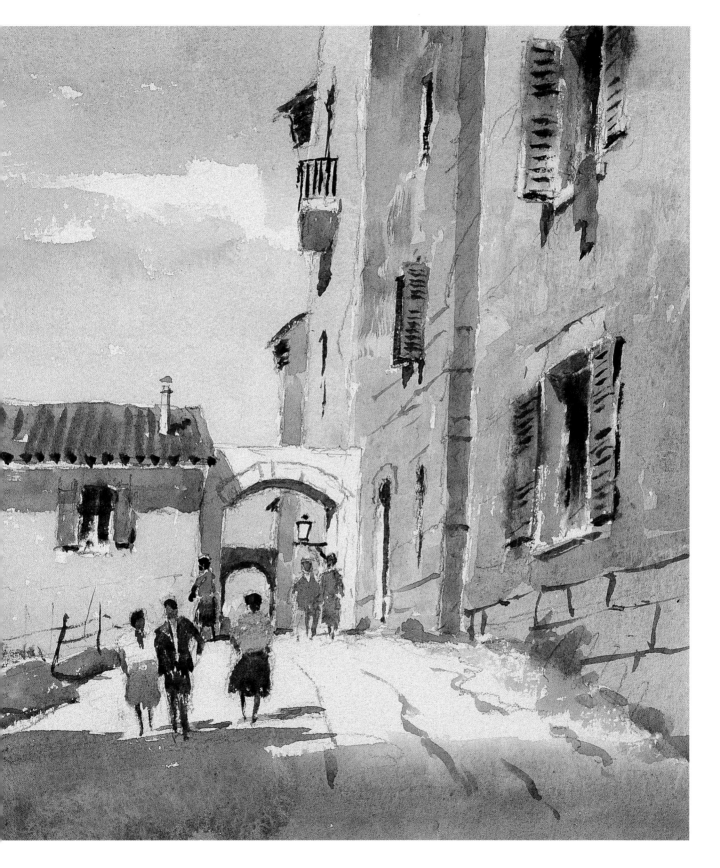

10 *Approach to a village.* 242 x 369mm (9 ½ x 14 ½in)

One last picture I would like you to look at in this chapter is **Figure 10**, *Approach to a village*. This type of subject is always a good stand-by when you are getting desperate to find one! A country road always has charm and it leads the eye into the picture in the same way as in **Figure 7**. The road helps with perspective by giving depth to a landscape and this is a most valuable quality.

The strong group of trees on the left with the cottage adjoining provides the main interest, but the sapling against the wall on the right gives enough counter-interest to preserve a reasonable balance.

Note that the cottage in this picture was drawn with a small brush and brown paint and not with a pencil. Try this method and you will find it gives your painting a certain looseness and freedom which is always a desirable element in watercolour painting.

I shall be referring to composition many times throughout this book as it is such a vital ingredient for a picture, but I hope I have made clear the main points to look for when selecting and creating a good composition. It is all about balance, positioning features, tone values and colour quality. I think the whole essence of composition will gradually dawn on you as you go through the book; it is not something that can be defined in just a few words.

TIPS AND TECHNIQUES

- Composition should be the first thing to think about when you are planning a painting

- Consider the linear movement within a painting, such as the use of a path leading the eye into the picture. Remember to balance the vertical and horizontal elements to give an overall harmony

- Distant elements in a landscape such as mountains or a castle will give an important impression of depth to the picture

- Try to achieve a balance between light and dark tones

- Carefully plan the colour elements in a painting at the composition stage – different colour combinations can dramatically change the mood of a painting

- Remember that you can use artist's licence to strengthen the composition of an observed landscape

CHAPTER 3
SKIES

*Sunny skies; cloudy skies; evening and early morning skies;
cloud shadows; and storm clouds*

The sky is one of the most important elements for the landscape painter to consider. It can set the whole tone and character of the picture and it is therefore essential to study the techniques for painting different types of sky. In Britain we are fortunate in having an enormous variety of weather conditions and so it is not necessary to travel very far to find varying sky examples. Constable once wrote, 'The sky is the source of light in Nature, and governs everything.' We must not forget this.

Let us start with a bright sunny day with blue sky and no clouds as shown in **Figure 11**. The first thing is to know how to lay a controlled wash on the paper. For this exercise we will not bother about the subject of the landscape.

With your paper laid flat on your sketching board, damp the paper all over with clear water and a fairly large brush (No. 8 or No. 10). When this is half dry, tilt the board to slope towards you and start painting at the top with your large brush and a fairly strong mixture of Cobalt Blue. Drag the brush from one side to the other with steady strokes, gradually working down the paper and making the blue application weaker by adding a little water in your palette. By the time you reach the bottom of the sheet, your brush should have almost no colour on it at all.

11 *Sunny day with clear sky*

Now we will try an early morning sky as shown in **Figure 12**. Damp the paper with clear water as before and start painting at the top with Cobalt Blue again, weakening the blue mixture as you paint. When you get a third of the way down, wash out your brush and use a weak mixture of Raw Sienna to start with, getting a little stronger as you near the bottom. The very last bit should be weak again. These early morning skies can vary and there could be a slight mist hanging in the air which would cause the yellow colour to vary in tone. You will need to look carefully at the sky before you start this delicate wash.

12 *Early morning sky*

Figure 13, *Autumn trees, Windrush*, illustrates this type of sky. In this instance the area of blue at the top is very pale.

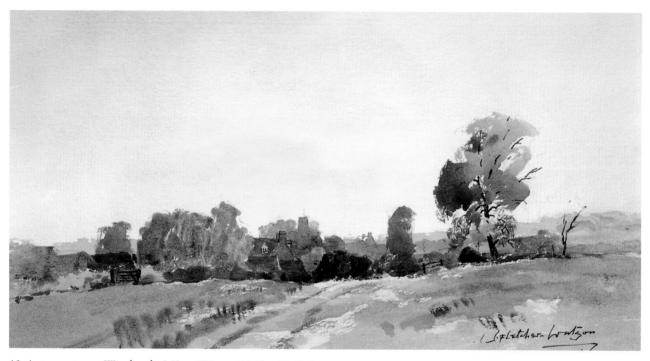

13 *Autumn trees, Windrush*. 260 x 470mm (10 ½ x 18 ½in)

14 *Evening sky*

In **Figure 14** we see that the low area of sky near the horizon is pink, the sun having just sunk down below it. Go through the same process as for a morning sky but stop the yellow wash two-thirds of the way down and change to a weak mixture of Light Red.

For all these cloudless skies, you can vary the shade of blue, yellow and pink used.

Turner was passionately fond of evening sunset skies as well as early morning ones. He was often out painting before breakfast to catch the light.

Now we will look at some cloudy skies, which I must admit are my favourite type. **Figure 15** shows a fairly typical skyscape with broken clouds allowing the blue sky to show through a number of gaps.

The painting procedure is first to damp the paper and when it is half dry, float in grey clouds with a No. 10 brush using a mixture of French Ultramarine and Burnt Umber. Start right at the top of the paper and work gradually downwards leaving white unpainted gaps as you go. The secret of a good cloudy sky is to make the grey areas large near the top and smaller as you go down, and the white gaps the same, from large to small. The reason for this is to give perspective in the sky in the same way as you have perspective on the land, for example when trees appear smaller as they become more distant. The clouds should also become less dark as they get further away, and sometimes I introduce a touch of Raw Sienna into the lower clouds.

Now for the pockets of blue sky seen in between the grey clouds. Starting at the top with a No. 8 brush and a fairly strong mixture of French Ultramarine, first paint a moderately large area of blue in one or two places, taking care to form interesting white

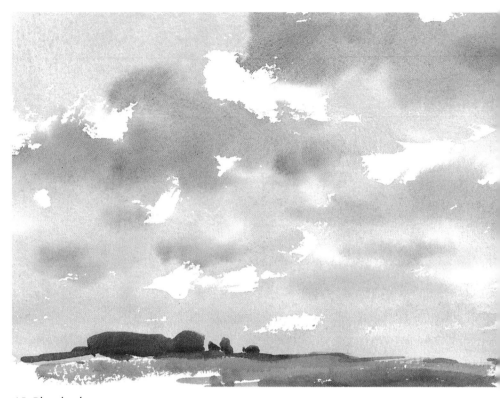

15 *Cloudy sky*

cloud shapes as you apply the blue paint. As you come lower down, make the blue areas slightly smaller and sometimes a long thin shape. They should also definitely be a weaker tone of blue.

At the lowest point the blue areas should be made very thin and painted a different tone of blue, either Cobalt Blue or Cerulean Blue, or even a very watered-down Winsor Blue. At this stage I usually find it necessary to reinforce the grey clouds with some slightly darker over-painting on some of the cloud areas.

Having given you the general principle of painting a cloudy sky, I must add that

there are of course many variations of cloud and sky arrangements. Sometimes you get a big area of blue sky near the horizon and the clouds are only high up over your head. At other times the whole sky will be grey cloud with no blue sky at all. But do not despise it – a grey day in the country can be attractive and mysterious.

Look now at **Figure 16**, *Beside Loch Awe, Scotland*, which shows a very lovely sky, full of movement and with only two small patches of blue visible. Note the foreground with sunlight and cloud shadows and the low cloud touching the top of the high mountain.

Sometimes a low cloud over a mountain is a very light grey; at other times it can be very much darker. This depends on the type of day and on the depth of the clouds. Really thick clouds prevent the sun from shining through and therefore look darker than thin wispy ones.

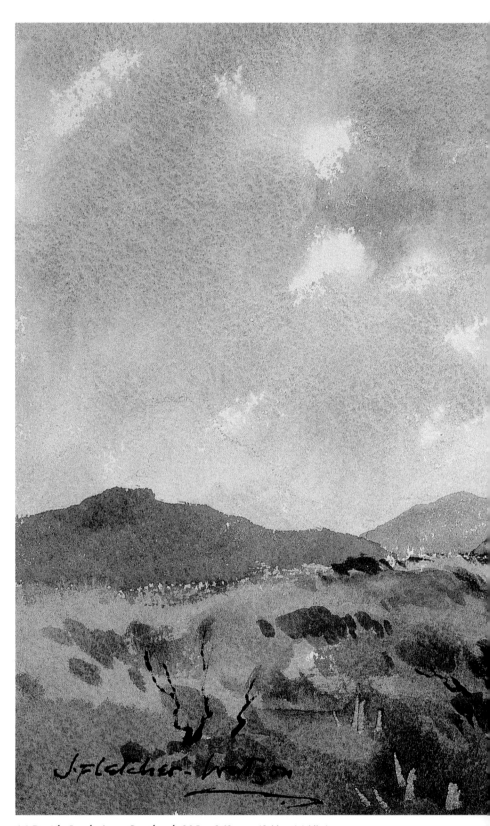

16 *Beside Loch Awe, Scotland.* 235 x 362mm (9 ½ x 14 ¼in)

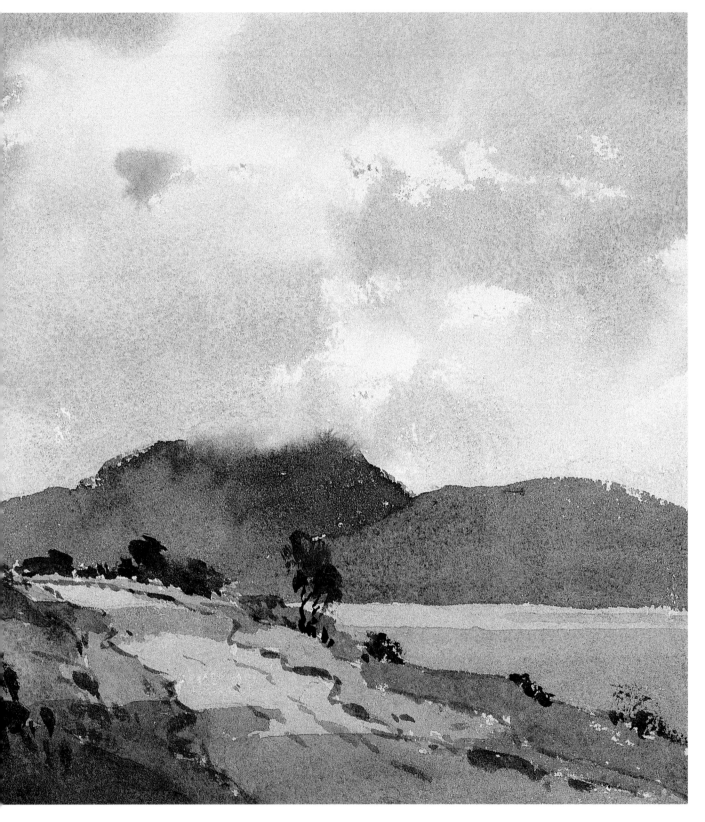

Figure 17 shows a good mixture of cloud and blue sky in mountain scenery and I will describe the method of painting clouds which are actually touching mountains. I have described this before in books and videos, but I know how many people still want help with it.

Having sketched in your mountain scene lightly with a pencil, paint the complete skyscape right down over the mountains to water level and allow this to dry completely. Then start painting the mountains one by one from the bottom upwards, keeping your paper in a horizontal position. When you get near the top of the mountain, take another small brush (No. 6) and with clear water paint over the top area of the mountain, including slightly above it. Do not use too much water. Now continue with the mountain with the first brush and a darker colour. Paint upwards into the damp area in a way that will give an interesting cloud shape. The secret of success is not to have a very wet brush full of colour, but make it rather a dry mixture so that the colour does not run out of control. When you have experimented with this on a rough piece of paper, you will see what I mean.

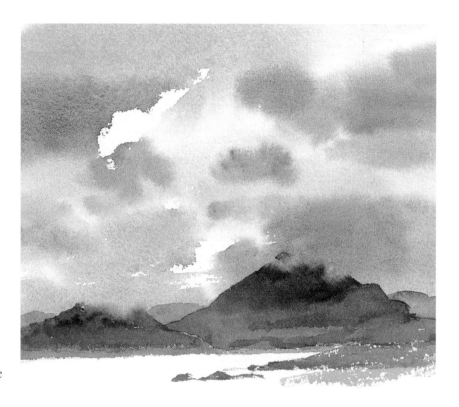

17 *Low cloud over mountains*

Figure 18, *Stonethwaite, Cumbria,* shows a very good example of low cloud both over the distant mountains in the centre and the closer mountains on the right-hand side. These low clouds soften the shapes of the mountains, adding tremendously to the atmospheric mood of nature and giving the feeling of movement in the sky, which is ever-changing in mountain regions. The cloud formations are very fluid, continuously making new patterns during the day. One minute there are blue patches of sky showing while just a few seconds later clouds can move across leaving no blue sky visible at all. It is necessary therefore for you to make up your mind before you start what sort of sky will suit your picture best, and there is no need to be concerned if it has completely changed by the time you have finished.

18 *Stonethwaite, Cumbria.* 318 x 477mm (12 ½ x 18 ¾in)

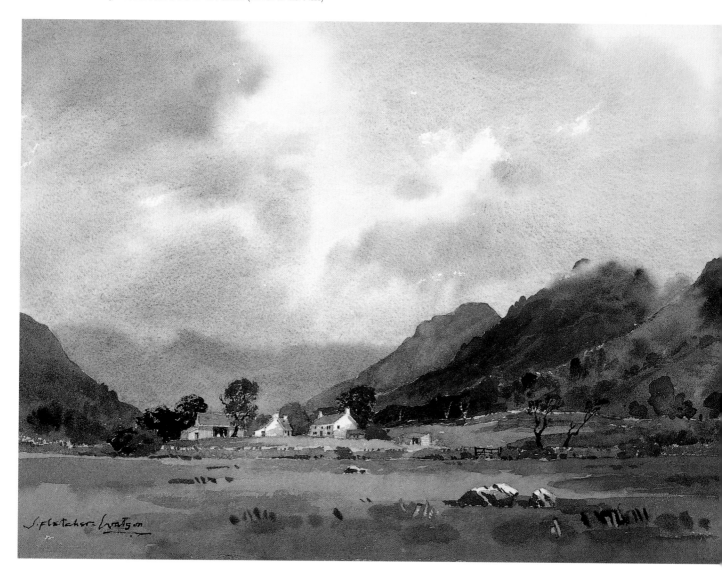

Figure 19, *Morston Marshes, Norfolk*, shows another type of cloudy sky, painted entirely with different strengths of Payne's Gray and a small touch of Raw Sienna in the right-hand clouds. The big dark clouds on the left side are moving across the landscape with vertical streaks of rain indicated. The whole sky area was kept damp so that the clouds had soft edges. It was all painted quickly so as to complete it before it was able to dry and cause hard edges. There are glimpses of sunlight on the land caused by narrow breaks in the cloud which cannot be seen from the viewpoint at ground level.

I need not show any more sky pictures in this chapter, although there is still a variety of skyscapes I could describe. In the ensuing chapters, a number of alternative skies can be seen in landscape pictures which depict other subjects such as trees, country buildings, mountains, water and even snow.

19 *Morston Marshes, Norfolk*. 318 x 477mm (12 ½ x 18 ¾in)

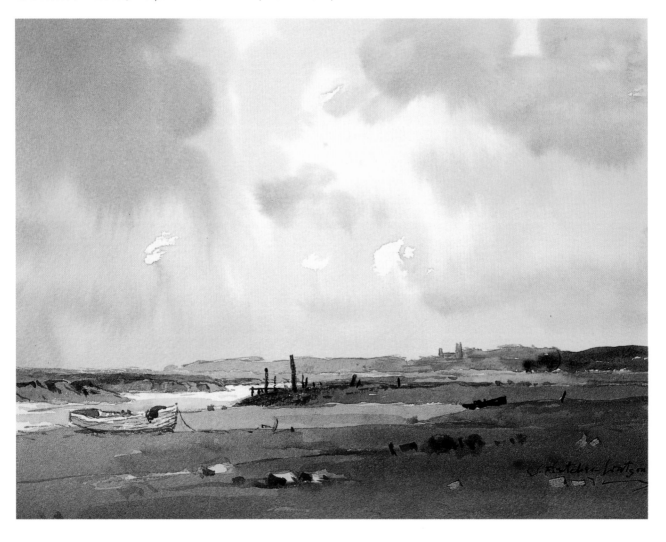

TIPS AND TECHNIQUES

- When painting a grey, cloudy sky, you can increase the impression of perspective by making the grey cloud areas and the white gaps decrease in size from the top of the page

- A blue sky always gets fainter towards the horizon, so make sure you achieve the same effect in your painting

- Grey storm clouds can be reinforced by over-painting them in a darker colour

- Do not use too much water when painting skies or the mixture may get out of control

- Low clouds will increase the impact of an atmospheric mountain scene

CHAPTER 4
TREES

Winter trees; summer trees;
autumn trees; trees with buildings; trees on country roads

In my years of teaching, trees have often proved troublesome to students. Even experienced painters sometimes find it difficult to paint trees convincingly. I can sympathize with this, but assure you that with plenty of practice you will eventually find that you can paint even the most challenging tree subjects. It is very much a matter of how you look at trees,

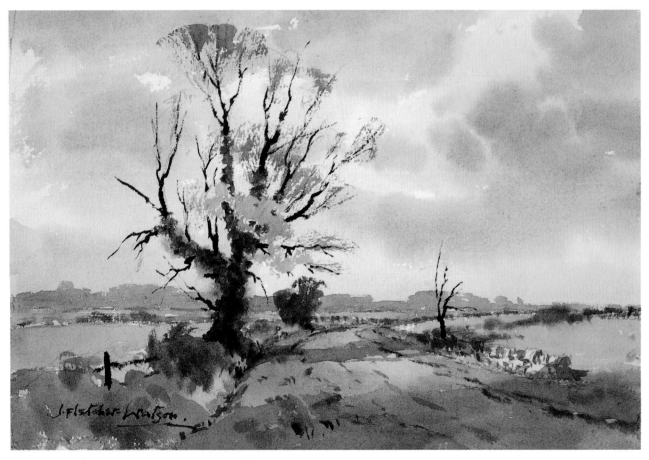

20 Winter ash tree. 235 x 362mm (9 ½ x 14 ¼in)

what type of brush you use, as well as what type of paper.

Look now at **Figure 20,** *Winter Ash Tree,* and you will see that the main feature is the tree in the foreground. A few yellow autumn leaves linger on, which lend interest. It is a good thing to learn a little about the anatomy of trees as seen in winter before painting a summer tree.

I am not going to describe the painting of this picture in full detail as I want to concentrate on the tree, but the method was briefly as follows. First I pencilled in the road and fencing, a bit of stone wall on the right and the distant horizon line. Then the grey, cloudy sky was painted and the tree was also tackled at this early stage. Next followed the yellow grass verges and yellow fields, and finally the distant belt of grey-blue trees, the cloud shadow in the foreground and the tree shadow across the road.

Figure 21 shows the bare bones of the tree painted straight onto a white sheet of paper. I used Whatman paper 140lb rough. Use good quality paper even for practice. I first drew with a 2B pencil the trunk and branches and also the central shape of yellow leaf foliage.

I then mixed Burnt Umber and Payne's Gray and started painting the main trunk from the bottom upwards using a No. 5 brush. The lower trunk and branches were covered with ivy creeper and I suggested this by making the edges rough and blobby. I had also damped the trunk area with clear water prior to starting, to obtain a slightly blurred effect. I changed to a No. 3 brush for the upper branches, some of which were very thin. Then I painted round the yellow foliage area.

Figure 21 shows how I have sketched in the outline of the

21 Winter ash tree, stage one

road and the distance purely to indicate the composition of the picture. Looking again at **Figure 20,** you can see that at the extremities of a winter tree the branches become extremely thin; they are just twigs and you should not attempt to paint them individually. They are best painted with a medium size brush (No. 5) and a rather dry mix of Burnt Umber and Payne's Gray. Use the side of the brush, not the point, and stroke it downwards on the paper, getting a little fan-shaped area of paint conforming to the treetop outline. This is known as dragged-paintwork.

Figure 22, *Winter Cotswold field,* is a rather small picture showing another winter tree with a field gate and farm track. You see what a charming subject this is and yet it is only a portrait of an old tree! Don't overlook this type of scene when on your country walk looking for a subject. Of course an interesting cloudy sky and some distant grey trees help to make a better picture.

This particular tree also has ivy on its trunk and main branches, but it has more winter twigs at the extremities than the one in **Figure 20**. Use the same method and paint these twig areas with dry brushwork. Note that the trunk and main branches are really very thick. You often see paintings of trees with the trunks much too thin. This is a sure sign they have been painted by an inexperienced artist, so don't fall into this trap yourself.

22 Winter Cotswold field. 152 x 235mm (6 x 9 ¼in)

Figure 23, *Leaning tree, autumn*, is another small sketch showing some autumn leaves already blown away revealing bare branches. See how attractive and poetical a leaning tree can be. Don't miss painting a tree like this if you spot one – it is better than fifty upright trees!

First of all I drew the line of the hedge, the tree trunk and a branch or two lightly in pencil. Then the sky was painted and when this was dry I used a No. 8 brush and washed in the tree foliage using Raw Sienna and Payne's Gray for the top lighter areas, and Burnt Umber and Payne's Gray for the lower darker areas of foliage (**Figure 24**). The great thing is to be bold with your foliage brushwork, using the brush sideways and dragging it quickly across the paper. It may look a mess at first, but when you put in the trunk and branches it all comes to life splendidly. Note that the bottom of the trunk is a lighter tone where it bends forward into the ground and catches the light.

23 *Leaning tree, autumn.* 152 x 235mm (6 x 9 ¼in)

24 *Leaning tree*, stage one

25a *Summer tree*, stage one

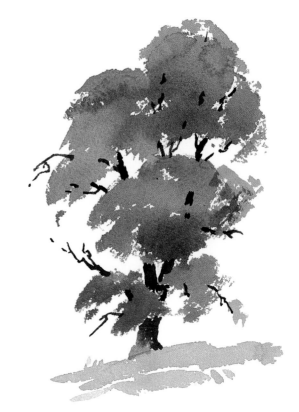

25b *Summer tree*, stage two

We will now look at a tree in full summer leaf. **Figure 25a** shows the first stage of painting, having first lightly pencilled in the trunk and main stems. I used a mixture of Raw Sienna and French Ultramarine on a No. 8 brush for the green foliage with a dash of Indian Red here and there to give variety of tone.

In **Figure 25b** you can see the effect of adding the trunk and branches, preferably while the foliage wash is still damp so that the branches merge slightly. No. 6 and No. 3 brushes were used for the trunk and branches, with a mixture of Burnt Umber and Payne's Gray.

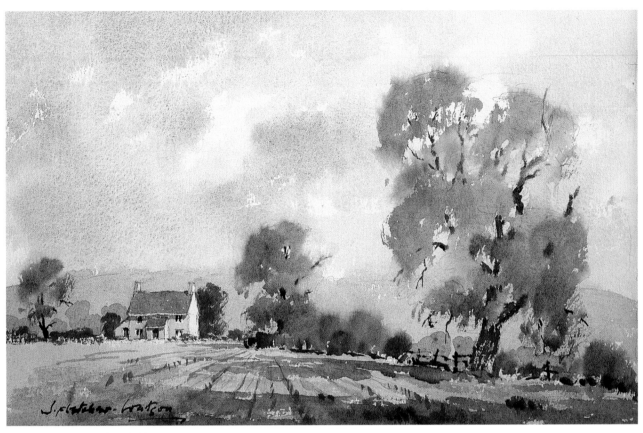

26 *Cotswold stubble field*. 317 x 476mm (12 ½ x 18 ¾in)

Figure 26, *Cotswold stubble field*, gives a finished picture of the stubble field and a very fine ash tree on the right which is of just the same type as that shown in **Figure 25**.

You will note this tree is leaning to the right which adds character, and it is casting a meaningful shadow across the stubble field. The adjoining field hedge and post and rails are attractive features in the general composition.

So far we have been dealing with individual trees; let us now look at trees collectively. **Figure 27a** shows the edge of a small wood near a lake. I was using Whatman paper (medium rough 140lb) and I drew a slightly curved ground line indicating a small rise with a pencil. No other pencil work was necessary.

I started painting with a No. 8 brush (see **27 b1**) with a green mixture of Cadmium Yellow, Winsor Blue and Burnt Umber. I first damped the area at the treetop with clear water, then I dragged the brush, which was well loaded with colour, sideways and downwards in a quick stroke. Using the brush sideways I could give a fairly flat top to this left-hand tree. I stopped the brush at the ground line and added a little more Burnt Umber to the mixture. I then painted the next tree (**27 b2**) with a fairly stiff mixture (not too much water), and with a quick downward stroke allowed the paper to breathe through the wash, showing glimpses of the sky. I then floated in a darkish green area at the bottom of the first two trees (**27 b1** and **2**) while they were still damp, adding a strong touch of Winsor Blue to the mixture for this.

Then I started painting the third tree (**27 b3**), slightly

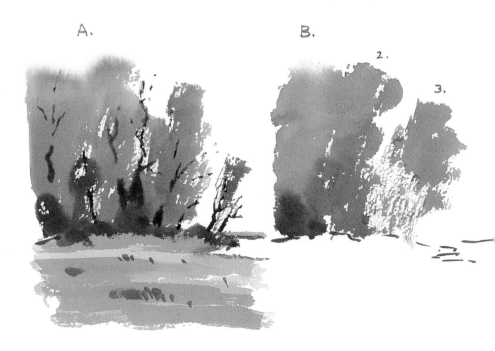

27a *Small wood near a lake*

27b Building up a group of trees

varying the colour by adding more Cadmium Yellow. I have stopped halfway down in order to show you clearly how the downward wash was put on. A couple of brushstrokes were all I used and only two more brushstrokes would be required to finish it.

Finally I put in the small sapling on the right (this is not shown in **Figure 27b**). Looking now at **Figure 27a** you can see how I hastily painted small dark washes at the base of all the trees using the same three colours. This was done while the first washes were still damp. Up to this stage, the whole process had taken about five minutes.

It was important to put in the tree trunks and branches

before the work was all dry. I quickly mixed Burnt Umber and Payne's Gray and with a No. 3 brush painted in the dark trunks and upper branches of all the trees. By keeping everything damp, a softer result was achieved which was more suitable for a tree subject than having the hard edges which are more acceptable when painting buildings for example.

Lastly, the foreground grass went in; the first wash was a mixture of Cadmium Yellow and Winsor Blue. The darker green shadow wash simply had Burnt Umber added. This second stage of painting darker foliage, tree trunks and foreground took roughly another ten minutes.

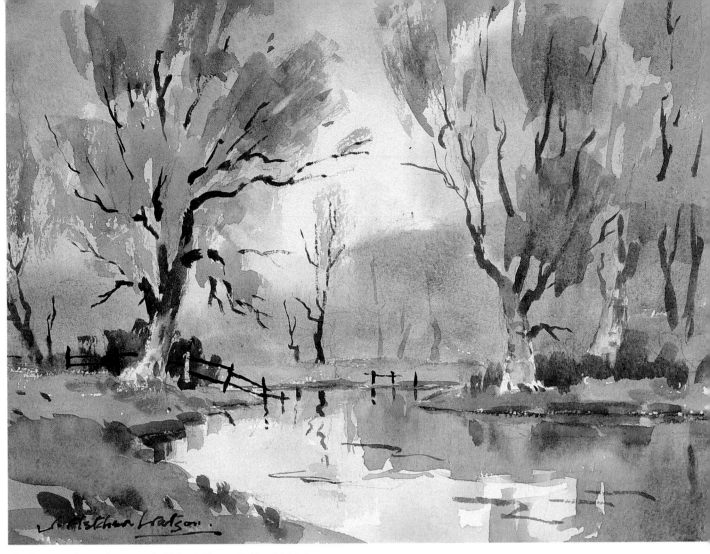

28 *Stream through a wood.* 235 x 362mm (9 ½ x 14 ¼in)

Another type of tree subject is shown in **Figure 28**, *Stream through a wood*. This is a tributary of the Windrush River quite near where I live and is a delightful little scene. Here it is illustrated in late autumn when the leaves were beginning to come off the trees, making the branches more visible. The distant part of the wood is a good example of how to paint background trees. It consists of a mixture of French Ultramarine and Light Red with a touch of Raw Sienna. I had damped the sky area with clear water so that the background trees would merge and give the necessary impression of distance.

The large willow trees in the foreground were a mixture of Raw Umber and Cobalt Blue. The tree trunk and branches were the usual Burnt Umber and Payne's Gray and were painted while the foliage was still damp in the same way as **Figure 27**. Note that the base of the trunks in **Figure 28** were left light.

A different type of treescape is shown in **Figure 29**, *Old Willow Trees*. This was painted on a grey cloudy day with a little mist and makes a poetical composition; the leaning tree in the centre is of great artistic value. Being autumn, the general colouring of rough grass and trees is a dull grey-yellow obtained with French Ultramarine, Light Red and Raw Sienna. The far distant line of woods uses only French Ultramarine and Light Red, giving a perfect blue-grey distance. The only other colour used in this picture was Burnt Umber for the branches and odd sticks in the ground which makes a total of four colours. The sky consisted of a mixture of French Ultramarine and Burnt Umber for the cloud area, and the small touches of blue sky were painted with French Ultramarine.

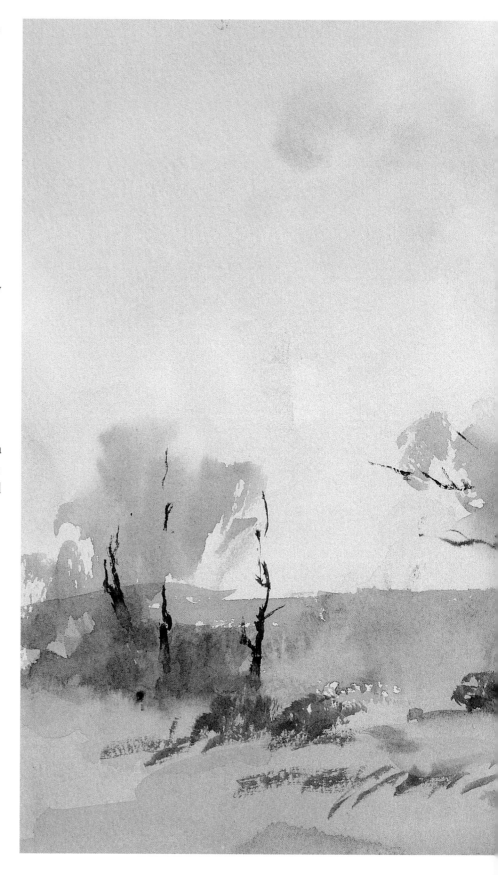

29 *Old willow trees.* 235 x 362mm
(9 ½ x 14 ¼in)

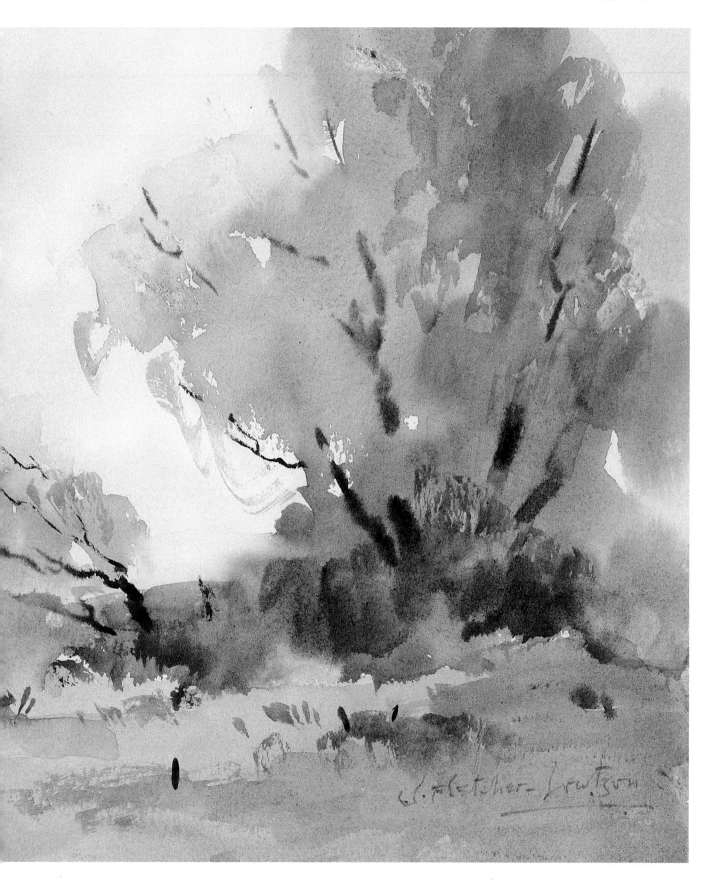

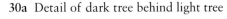

I have included **Figure 30**, *Seathwaite, Cumbria*, here firstly because it is such a well-balanced landscape where trees play an important part, and secondly because I have used the old trick of placing a dark tree behind a light tree. J. S. Cotman used this ploy to great effect. This is not to say there were not two trees together by the bridge, as there were, one behind the other, but I exaggerated the dark tone of one tree slightly. A detail of these two trees is shown in **Figure 30a**.

The two middle-distant trees, roughly in the centre of the picture, made a good foil to the large trees on the left, and the small trees on the right were painted in light tones which helped give distance.

I am specially fond of this little picture as it satisfies my eye for balance and depth. The mountains have low cloud on them giving atmosphere and the bridge is a good focal point. The sheep are moveable features which can be placed in exactly the right position, thus completing the overall harmony. The sky is all part of the composition, with carefully placed small areas of blue peeping through the clouds.

30a Detail of dark tree behind light tree

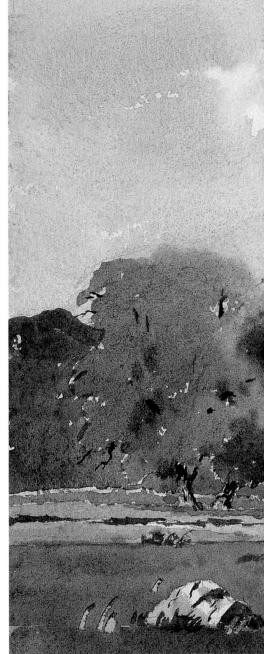

30 *Seathwaite, Cumbria.*
235 x 362mm (9 ½ x 14 ¼in)

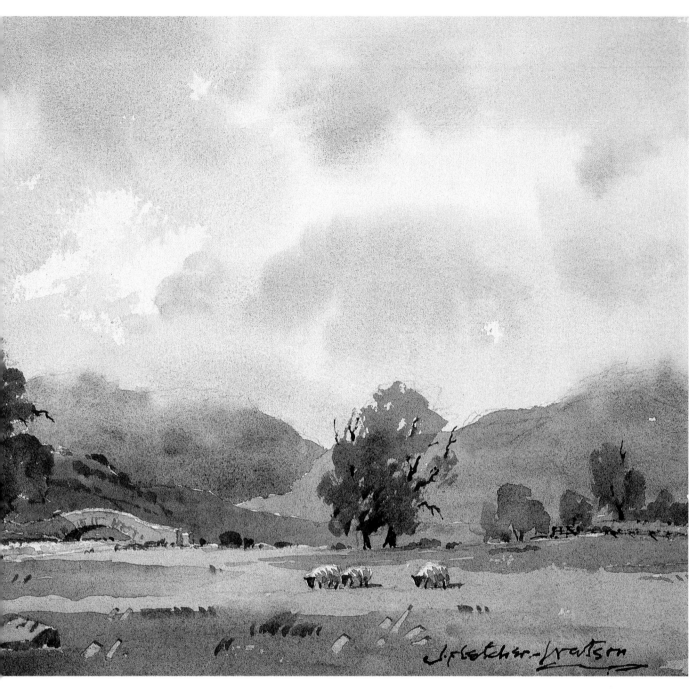

Before leaving this chapter I must just show you two examples of trees with buildings. There are some buildings which depend very largely on the presence of trees to make them into attractive compositions for the painter as you will see in the following examples.

Figure 31, *Windrush village*, seen from across the fields, is a nice view of cottages strung out in a line with the church tower in the middle giving a focal point. On the right there is a tall group of lime trees forming an invaluable background to emphasise two of the cottages. This was painted in high summer when trees can be really dark, and how splendidly they make the buildings and chimneys stand out. There is also part of a tree showing to the left of the tower which has the same effect, and some low treetops to the right of the tower giving emphasis to the low brown-roofed outbuilding. The small tree and shrub are useful features, breaking up the elevations of the left-hand cottages. These trees give tremendous strength and character to the view which without them would be far less interesting. My colours for all the trees were mixtures of Cadmium Yellow, Winsor Blue and Burnt Umber.

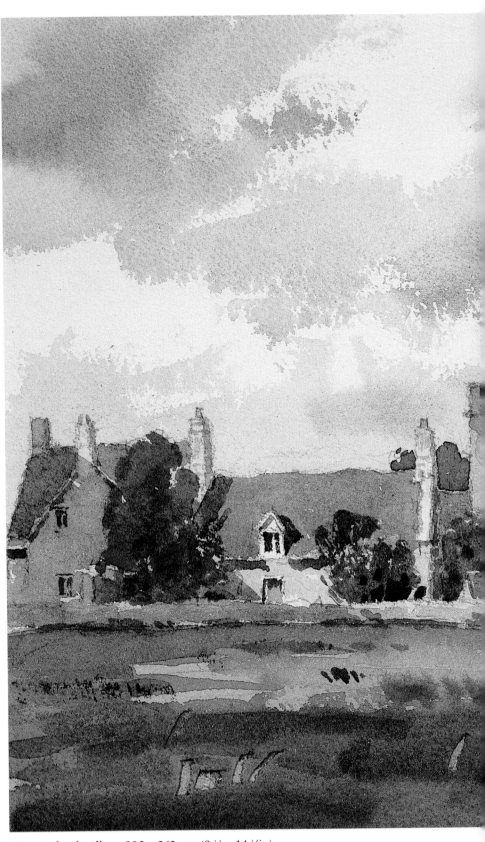

31 *Windrush village.* 235 x 362mm (9 ½ x 14 ¼in)

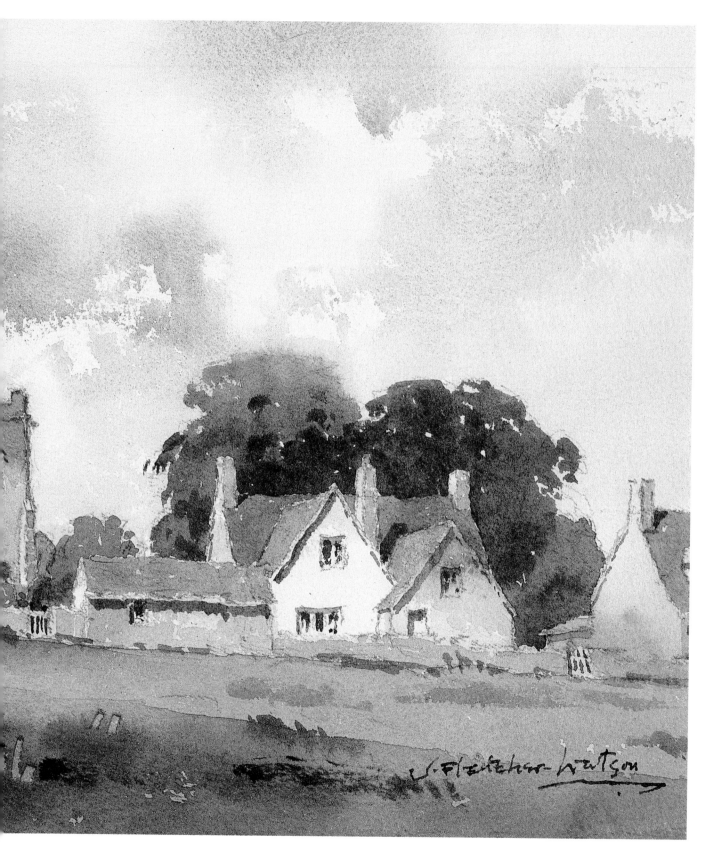

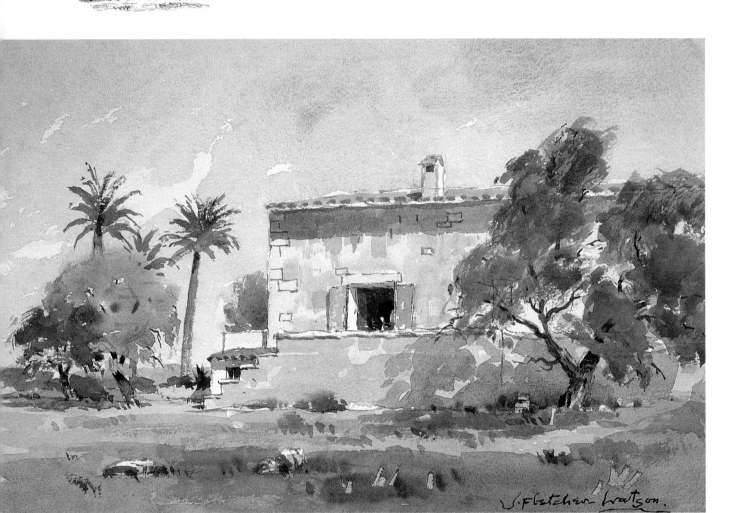

32 *A Majorcan farmhouse.* 235 x 362mm (9 ½ x 14 ¼in)

Lastly we have **Figure 32**, *A Majorcan farmhouse*, which was painted on the spot in May. The tree on the right is an ancient olive which was casting a lovely shadow on the adjoining wall. This tree, together with the two palm trees on the left, made an excellent composition. Note also the small grey tree peeping round the corner of the house which helped to give contrast to the stonework. This is a very simple subject which would be quite without interest had it not been for the trees.

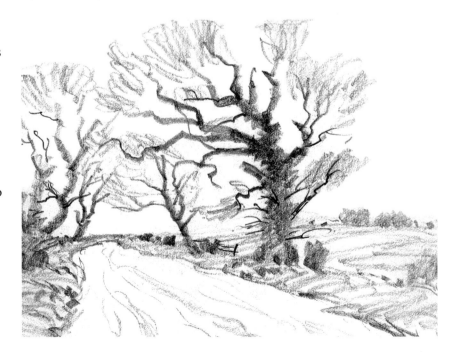

I hope I have given you some useful examples to enable you to paint some good tree studies and gain a knowledge of the techniques required to form a good tree landscape.

Of course if you are going to get really interested in trees you should study the different types closely. For instance the big tree on the right in **Figure 26** on page 37 is an ash tree which is always a very graceful tree type. **Figure 29** on pages 40–41 shows willow trees, which have a distinctive blue-green colour. The large trees in **Figure 31** on pages 44–5 are limes. An oak tree tends to be rather square in shape owing to individual branches growing at right angles to each other. In the autumn trees turn very different colours; for example the leaves of an autumn beech tree are a glorious yellow-red.

TIPS AND TECHNIQUES

- Familiarise yourself with the distinctive anatomy of the different species of trees observed in winter before painting them covered with foliage

- Don't attempt to paint twigs individually – use a medium-size brush with a dry mix of Burnt Umber and Payne's Gray.

- Dragged paintwork can effectively suggest the delicacy of treetop outlines

- Use careful observation to avoid underestimating the weight and width of the trunk and branches of a tree

- Use bold brushwork for foliage, using the brush sideways and dragging it quickly across the paper

- Adding the trunk and branches while the foliage wash is still damp will integrate the branches effectively with the colour of the foliage

CHAPTER 5
COUNTRY BUILDINGS

Welsh farm cottage; Norfolk water mill;
Northumbrian castles; Suffolk farm buildings

By country buildings, I am referring here to buildings in the British Isles. They are not quite the same as those in, for example, America, France or Australia, but the principles governing the painting of such buildings are fairly similar the world over. I am constantly fascinated by the marvellous variety of world architecture, from tenth-century castles and medieval Tuscan hilltop villages to the gracious houses and churches of eighteenth-century New England.

The small, simple dwelling in its lovely setting shown in **Figure 33** was chosen mainly for its superb composition. I placed the group of buildings slightly to the right of centre, and the sloping ground made an attractive feature. The farm track leads the eye into the picture, and the thin leaning trees on the right give a lovely foil to the horizontal blue

mountain range behind them. I used Saunders-Waterford paper which has a slightly rough surface and is a light cream colour.

I decided not to use any pencil, but to draw with a very small brush and a mixture of Burnt Umber and Payne's Gray. With this method you cannot afford to make any mistakes! The final picture benefits by having a loose, simple clarity. If you are a beginner, I would recommend using a pencil.

Having completed the drawing of the cottage, trees and road, I painted the sky using mixtures of French Ultramarine and Burnt Umber, and Cobalt Blue for the two patches of blue sky. These washes were carried over the mountain areas down to the ground, carefully painting round the cottage outline.

Figure 34 shows the next stage. I completed all the

buildings as follows. The roofs were Cerulean Blue and Light Red giving a good greenish-grey Welsh slate colour. The stone walls followed using Cobalt Blue, Light Red and Raw Sienna with plenty of water for a light tone. When dry, a slightly darker tone was applied to give a stone texture. Then the windows and lean-to shed openings were painted with Burnt Umber and a touch of French Ultramarine. When these were dry, a much darker mixture was painted on parts of the shed openings and on the thin line of the porch door. Then came the trees showing behind the buildings, which were painted using Burnt Umber and Winsor Blue, and finally shadows under the eaves of all the buildings with Cobalt Blue, Light Red and a touch of Raw Sienna. The dark background trees were painted last of all.

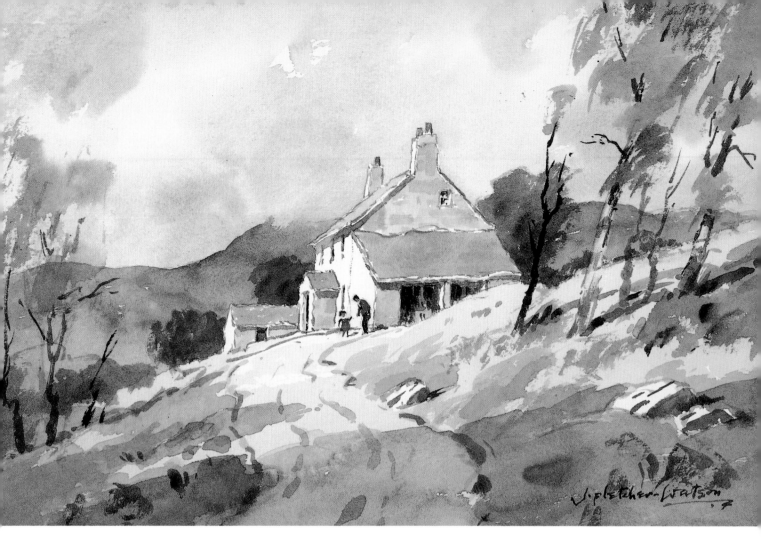

33 (Above) *A Welsh farm cottage*. 235 x 362mm (9 ½ x 14 ¼in)

34 (Below) Detail of Welsh farm cottage

To complete the whole picture (**Figure 33**), I painted the distant mountains with French Ultramarine and Light Red, the grass areas with Cobalt Blue and Raw Sienna, and the ground shadows with a stronger mixture of the same colours. The foreground tree foliage was painted with a mixture of Raw Sienna and French Ultramarine, while the strong foreground shadow across the track consisted of a mix of French Ultramarine, Light Red and a touch of Raw Sienna. The rocks featured shadows of the same mixture but in a darker tone.

Another type of country building is shown in **Figure 35**, *A Norfolk water mill*. This lovely old building is at Marlingford, near Norwich. As you will see, it is partly clad with weatherboarding and painted white which is fairly typical of these mills.

The technique of painting this mill was first to make a careful pencil drawing and as you can see the pencilwork still shows on the weatherboarding, which was intentional. The perspective is important as the viewpoint from where I was sitting was well below the farm road leading over the bridge. Some careful drawing was needed for the curved wooden brackets supporting the left-hand gable and also for the projecting gantry in the right-hand roof. A detail of the painting of this feature is shown in **Figure 35a**.

35 *A Norfok water mill.* 235 x 362mm (9 ½ x 14 ¼in)

Incidentally, you will notice
how valuable the mass of
background trees is, giving a
dark tone against the light
walls of the mill and making
the whole building stand out in
bold relief.

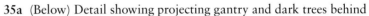

35a (Below) Detail showing projecting gantry and dark trees behind

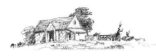

Figure 36, *Norham Castle, Northumbria*, shows a castle located on the outskirts of Norham village, which is easily accessible. I painted this on a recent trip where I was exploring Northumbria for the first time, and how rewarding this area was with its exciting old castles, rivers, bridges, unspoilt villages, rolling hills and stone outcrops.

I have selected this subject mainly for its simplicity. All we have here is an easy-to-draw castle tower, adjoining trees and a road. Note that the composition has the castle slightly to the right, well placed trees, an uphill road and the big foreground shadow, cast by trees out of the picture on the right.

The colours used for the castle were varying tones of Burnt Umber and French Ultramarine and for the rest of the picture Cadmium Yellow, Winsor Blue and Raw Sienna.

Figure 37, *Bamburgh Castle, Northumbria*, shows another castle, this time standing in majestic isolation on its rocky eminence on the edge of the sea. It was painted in October when the colouring was very lovely on a stormy day of dark clouds with glimpses of sunshine. The surrounding ground of dying grasses and shrubs gave the impression that the view had not changed for a thousand years. I painted this picture quickly, as there was an east wind blowing off the sea and I was getting cold. It took in all about an hour and a quarter. I always advise painting watercolours quickly so that you leave out unnecessary detail. This is a good thing because it forces you to concentrate on the essentials and avoid fussiness.

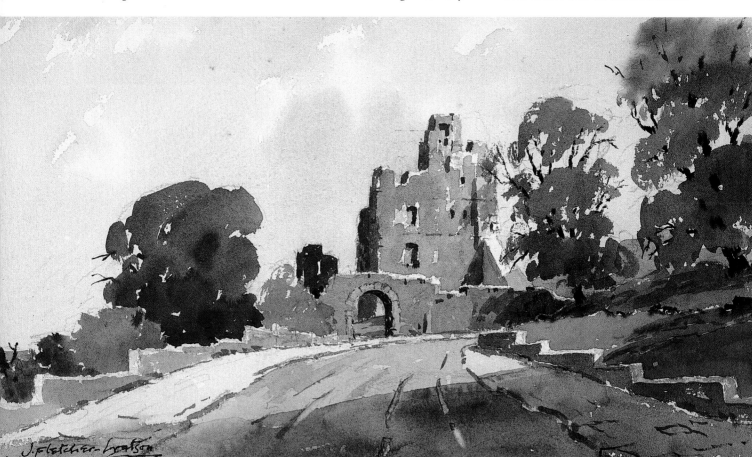

36 Norham Castle, Northumbria. 266 x 476mm (10 ½ x 18 ¾in)

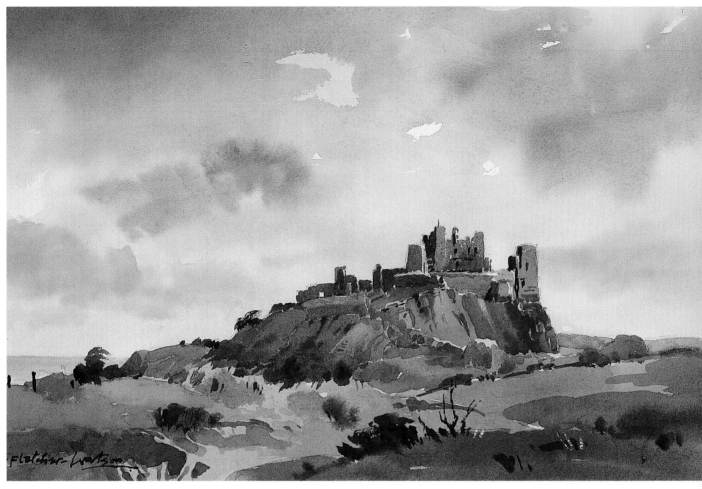

37 Bamburgh Castle, Northumbria. 318 x 476mm (12 ½ x 18 ¾in)

I was using Whatman NOT paper and I drew in the outline of the castle and the cliffs below with a 2B pencil, just indicating the rough foreground. The sky was then painted entirely with Payne's Gray keeping the clouds fairly fluid. When this was quite dry, I put in the castle itself using a No. 7 brush with a good point. The colours I used were Burnt Umber and French Ultramarine, varying the tones for different parts of the building and putting in the walls and windows which were in very dark shadow directly after the first wash had dried. I carried this wash down over the cliff areas adding touches of Indian Red and a green mixed from Cadmium Yellow and French Ultramarine. A small area of bright grass in a vivid green at the top left was painted with a Cadmium Yellow and Winsor Blue mixture. The areas of shadow were added with darkish tones while the paper was damp. Some small parts of wall or rock were left unpainted as they were catching the light.

I then tackled the grass foreground using the same colours as mentioned above but adding a large grass area to left of centre using primarily Raw Sienna. To the right I used quite a lot of Indian Red.

Although painting quickly, I still managed to apply a succession of washes in the right order so as to build up areas of colour and texture where required.

53

Figure 37a shows a detail of
the right-hand half of the
castle and you can see how
loosely the wall shadows and
windows are painted. There is
no need to be too precise with
this type of rugged building.

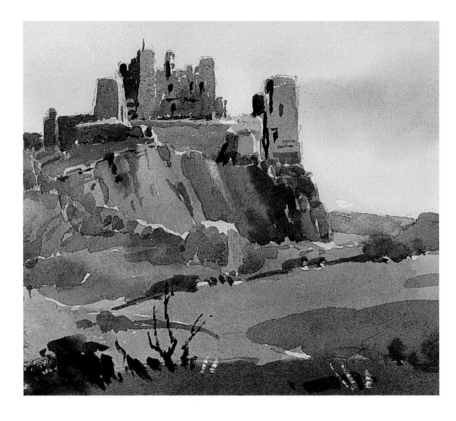

37a Detail showing right-hand half
of castle with loosely painted
shadows, windows and cliffs

This chapter could not be
complete without including
buildings to be found on a
farm and **Figure 38**, *Farm
buildings, Dedham*, shows an
interesting group of barns and
sheds. The buildings in
themselves are not of great
architectural merit, but it is
their setting which gives this
picture such charm. The
church tower can be seen over
the treetops and immediately I
saw this view I knew it would
be a winner.

The composition was
almost perfect and I took up
my position just to the left of
the farm track so that it ran
into the picture from right to
left. A minor adjustment was
necessary to the big tree on the
left as it was too far away from
the buildings, and I solved this
by moving it a short distance
to the right. The open-sided
barn in the centre was the focal
point and its interior was very
dark indeed. I wanted an item
of secondary interest in the
buildings on the right, so I
made a dark opening in the
low blue-roofed shed. This
gave just the desired strength
of tone for the composition.

The painting process was
fairly straightforward. The sky
was of course washed in first.
Then I tackled all the buildings
using various mixtures of
Burnt Sienna, Cobalt Blue and
Raw Sienna, and for the dark
interior of the barn and shed,
Burnt Umber and French
Ultramarine. The straw bales
in the barn were a weak wash
of Raw Umber.

I next painted the various
tree groups with mixtures of
Raw Umber, Winsor Blue and
Burnt Sienna. There was a
distinct touch of autumn in the
air and the trees reflected this.
The foreground grass was
painted using Raw Umber and
a little Winsor Blue. I left the
ground immediately adjacent
to the barn white and
unpainted, as the light earth
was catching the sunlight.

The foreground cloud
shadow was simply a darker
mixture of the original grass
colour, and over the track the
shadow was Cobalt Blue and
Light Red.

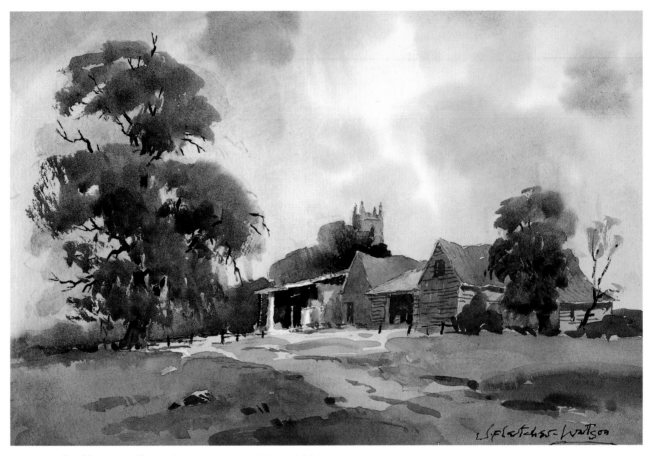

38 *Farm buildings, Dedham.* 318 x 477mm (12 ½ x 18 ¾in)

TIPS AND TECHNIQUES

- A background of dark trees can effectively define the building you are working on

- Even when working quickly, try to apply washes in an order that will build up the required colour and texture

- When painting buildings, there is no need to be too precise – too much detail may not actually enhance the overall effect

- When looking for a composition with buildings, the setting can give a picture as much charm as the buildings themselves

CHAPTER 6
TOWN BUILDINGS

Hill town, Crete; Roman ruin at Merida, Spain; old houses on bridge,
Durham; Roman bridge at Cordoba, Spain; ancient town in Normandy; city of Santiago
de Compostela, Spain; and quiet corners of Suffolk

In this chapter I show how you can draw inspiration from a wide diversity of architectural styles. **Figure 40** (opposite) shows a remote and simple little habitation. These stone buildings are very typical of Cretan architecture and their simplicity lends charm. The small shop on the left with a sun-blind is in shadow, while the other buildings are thrown into sunny relief.

The drawing work was done with the small brush and brown paint used for the Welsh cottage in the previous chapter. **Figure 39** shows a detail of the central area including the stone steps. It clearly demonstrates where a sketchy line is most effective. I used a limited palette of Raw Sienna, Burnt Umber and Cobalt Blue for most of the picture. For the figures, roof tiles and tree I added Burnt Sienna and Winsor Blue. The key to success here is tone value. The darkest item is the door opening under the steps.

39 Detail of hill town, Crete

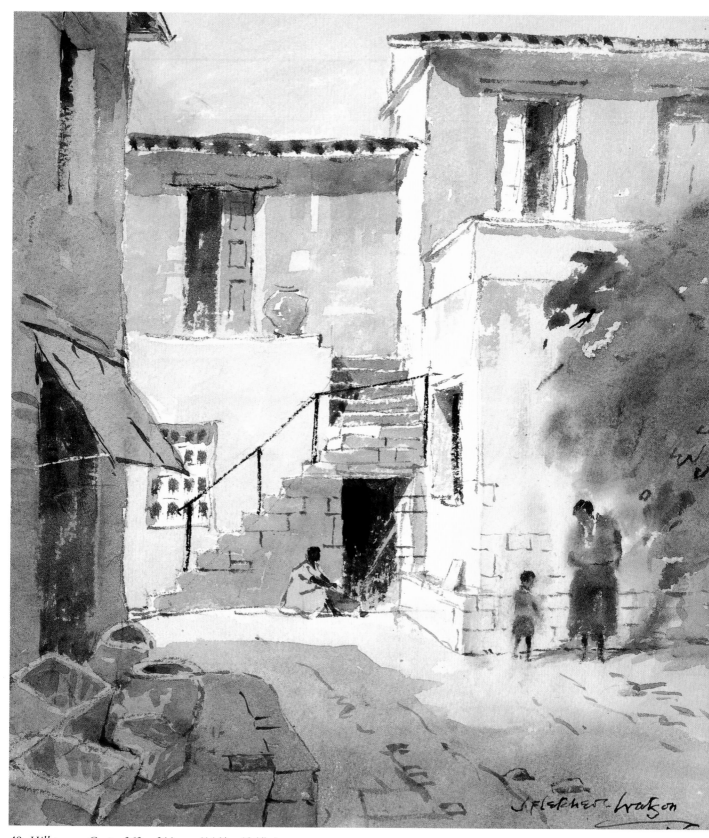

40 *Hill town, Crete.* 362 x 311mm (14 ¼ x 12 ¼in)

Moving now to Spain, **Figure 41** was again a very simple scene crying out to be painted. It was essentially a strong sunlight subject; on a dull day it would be of less interest.

I was using a NOT surface paper and I drew the whole subject with a 2B pencil quite quickly and roughly (by which I mean that the lines were not dead straight). At the same time it was drawn accurately enough to ensure that the archway was the right proportion. The very fact that this Roman structure was nearly 2,000 years old made one marvel! The main feature was its chunky stone quality. The general colouring was Burnt Umber mixed with French Ultramarine, giving various tones of grey-brown. Note how the stone paving joints help with the perspective and depth. The tree showing over the top was extremely useful, throwing the structure into splendid relief.

I mainly used a No. 8 brush, painting quite quickly with a strong mixture of colour which gave the final result a freedom and simplicity which is so desirable in watercolour. This subject could easily have been overlooked, but with the sunlight and shadow it was transformed into something very special.

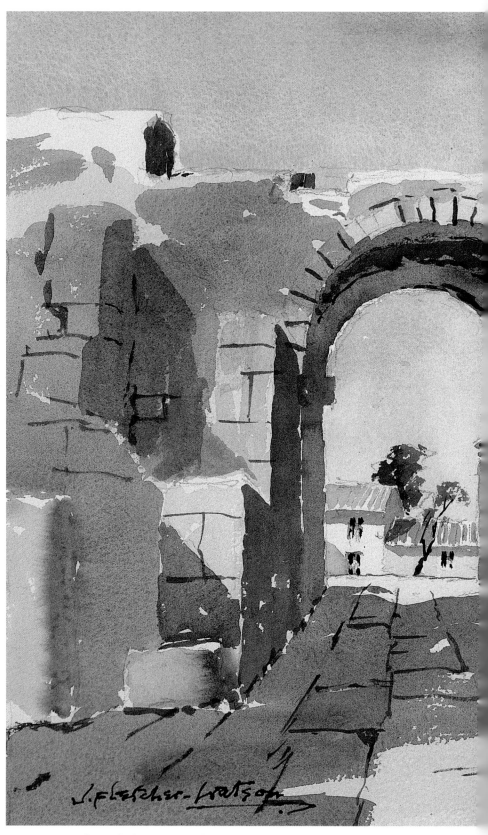

41 *Roman arch amphitheatre, Merida.* 318 x 477mm (12 ½ x 18 ¾in)

Figure 42, *Elvet Bridge, Durham*, is a subject hard to find in Britain these days. Very occasionally you will come across a tollgate cottage built onto a river bridge, but several buildings in a setting such as this is virtually unheard of. I had to wander about both sides of the bridge before I could settle on a desirable viewpoint which had both sun and shadows and showed the overhanging houses cantilevered off the stone bridge walls in this most daring way.

A careful drawing in pencil was first carried out on NOT surface Whatman 140lb paper, and then I immediately laid in the cloudy sky washes using French Ultramarine and Burnt Umber. Having completed this I could judge the tone values for the stone, brick and whitewashed walls of houses and the warm yellow-grey stone of the bridge. The darkest darks were the shadows under the arches and the background trees.

The order of painting was first of all the roofs, then the windows, followed by light washes on the walls, including the bridge, and the dark trees seen through the arches. Then the walling tones were strengthened and stone joints added. The shadows under the arches and roof eaves and under the overhanging buildings were then painted. Finally came the river with a light Payne's Gray wash all over and then the reflections with loose brushwork to indicate the movement.

The colours used for the buildings and bridge were Raw Sienna, Burnt Sienna, Burnt Umber, Cobalt Blue, French Ultramarine and Payne's Gray. The paints were mixed in various ways to give the required colours for walls, roof shadows and water reflections.

A detail of the central part of the picture (**Figure 42a**) shows the brushwork under the cantilevered houses.

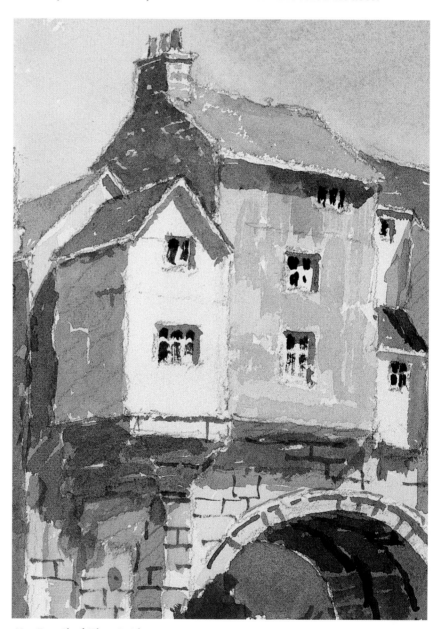

42a Detail of Elvet Bridge

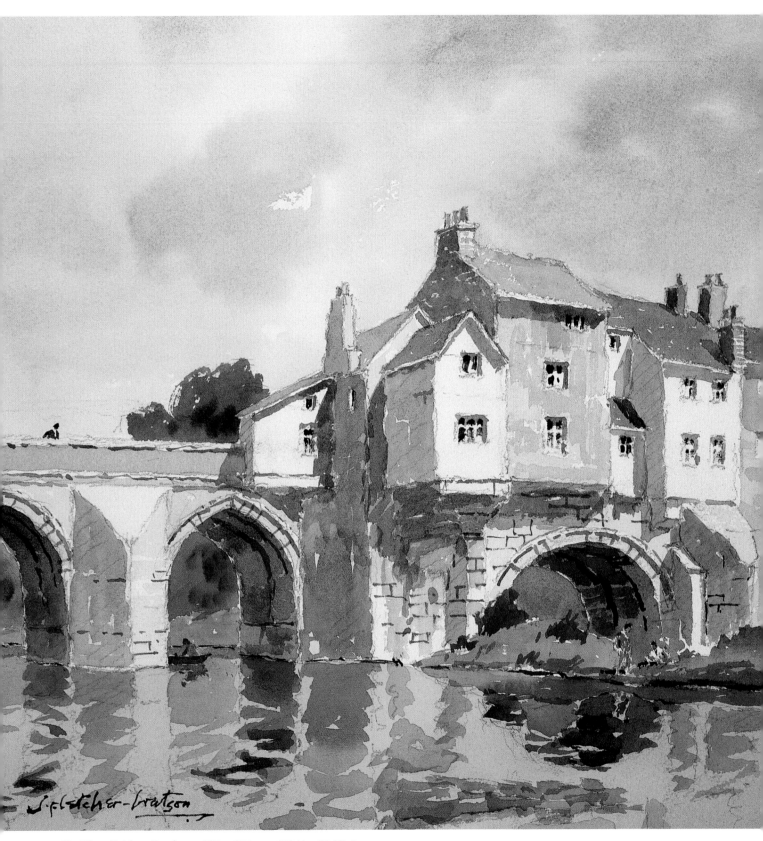

42 *Elvet Bridge, Durham.* 337 x 311mm (13 ¼ x 12 ¼in)

Figure 43, *The Roman Bridge, Cordoba*, is another Spanish subject seen in the typically strong Spanish sunlight. Note the sharp shadows under the arches and the roof eaves of the central water mill.

I ventured off the main road down the sloping track as some instinct told me I should find a good view down at water level, and I was rewarded with this superb composition. Everything was there, the arches, the solid stone buildings and the rugged foreground rocks, scrub and mud! What more could a painter want; the irregular skyline was calling out to be put down on paper and I revelled in this discovery!

43 *The Roman Bridge, Cordoba.* 318 x 477mm (12 ½ x 18 ¾in)

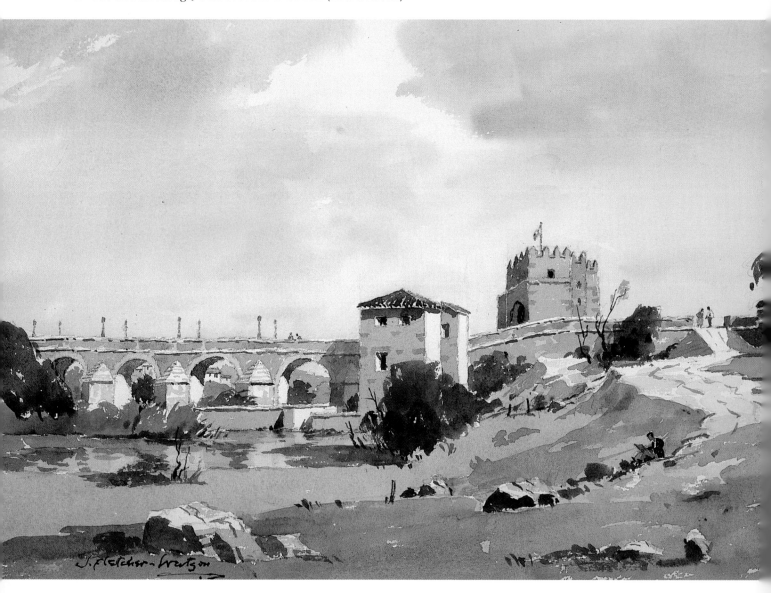

I will not go through the whole painting in detail but suggest that you first paint yourself the small area shown in **Figure 44** which shows the old Moorish mill building. Draw this on a small piece of watercolour paper about 178 x 254mm (7 x 10in) and then start painting. Begin with the red tile roof with a No. 5 brush and a mixture of Burnt Sienna and a touch of Cobalt Blue forming the sloping lines of Roman tiles. Then paint the walls of the mill and bridge with a No. 8 brush and a subtle mixture of Cobalt Blue, Light Red and Raw Sienna which will give a warm, yellow stone colour. Now with a

No. 3 brush draw in the thin shadow lines of the projecting stone string-course mouldings using Burnt Umber. Follow this with the deep shadows in the windows and also the dark arch shadow using Burnt Umber and French Ultramarine. For the strong sloping shadow cast by the millhouse onto the bridge, use the same colours but not quite such a dark mixture. This is the most important shadow of all, as it brings the whole picture to life. Finally the large bush in the foreground was painted using Burnt Umber and French Ultramarine again, but with a darker mixture and a No. 8 brush. Other minor

details are touched in with suitable mixtures of the colours already mentioned.

You will find that this small exercise will teach you all you want to know for painting the whole picture on a larger piece of paper. Note the right-hand walls of the arch and the building are not painted at all as the intense blazing sunlight makes them look quite white.

The colours used for the whole picture, including the greens and greys in the foreground and the blue-grey sky are as follows: Cadmium Yellow, Raw Sienna, Burnt Sienna, Burnt Umber, Light Red, Cobalt Blue, French Ultramarine and Winsor Blue.

44 Detail of the Roman Bridge, Cordoba

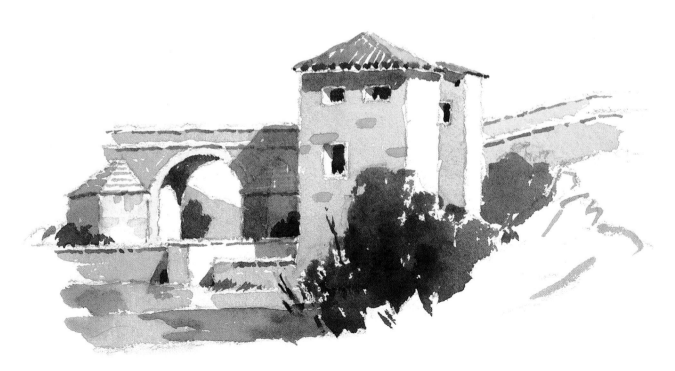

Figure 45 shows seventeenth- and eighteenth-century architecture in northern France, with the steep roofs and spires of a medieval chateau in the background. The shadows were much more interesting when looked at from straight across the street rather than from a diagonal viewpoint. Incidentally, the perspective is also much easier with a frontal view.

I used Whatman 200lb paper with a NOT surface, suitable for detailed work.

I first drew the whole scene with a 2B pencil, indicating the shadows which can change surprisingly quickly. This is only necessary for a large subject like this when it takes a little while to reach the final stage of painting.

The positioning of figures is a very definite part of the composition. The two figures crossing the road were carefully kept to one side as a central position would have made an unhappy focal point and divided the picture in two.

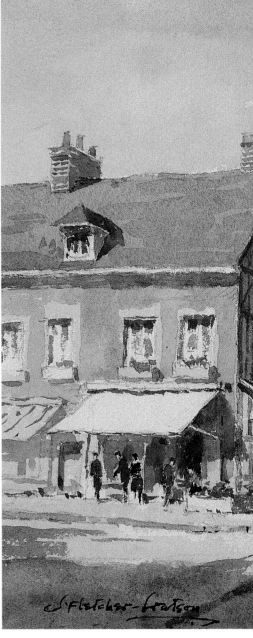

45a Detail of house at Gaillon

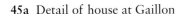

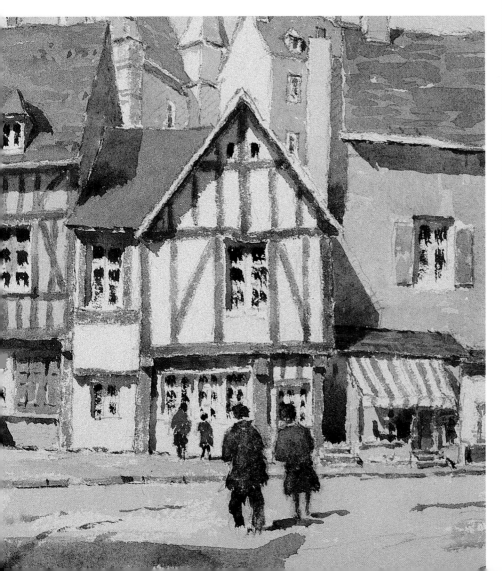

Having completed the drawing work I started to paint the sky. Then I worked on the roofs and gave a light tone to the walls. The walls of the centre, gabled house were left unpainted to show the

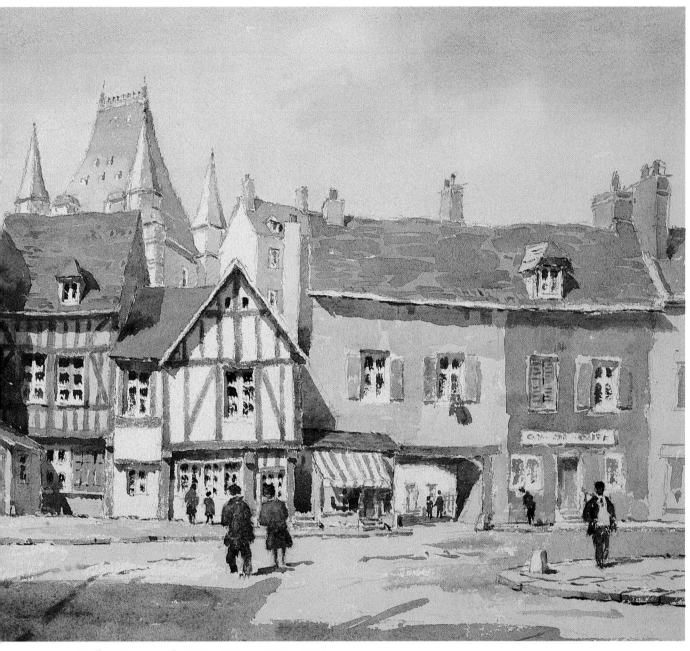

45 *Gaillon, Normandy.* 318 x 477mm (12 ½ x 18 ¾in)

white of the paper. The next stage was to add the windows and doors. The figures were then painted in, and next the all-important shadows on the buildings and the foreground. Finally, wall textures were strengthened and shadows darkened selectively, which gave emphasis to certain parts of the picture.

Figure 45a gives you an idea of the painting technique. Note that the heads of all the figures in the picture, whether in the foreground or in the distance, are at the same level. By painting your figures in this way you will ensure that you achieve the right perspective, giving a sense of distance to the picture. This is a golden rule of perspective and well worth remembering.

Figure 46, *Santiago de Compostela, Spain* (opposite), is a view of a wonderfully unspoilt city with narrow streets and spacious squares which has to be seen to be believed. This particular view immediately caught my eye as a subject for an upright picture. Unlike **Figure 45**, which shows a front elevation of a street, this was a view with strong perspective and depth, and it was reminiscent of one of Bonington's lovely street scenes.

Note the sky shape which is broken up by the jutting out roof eaves and the church pinnacle in the background. This picture is a good example of a vertical subject with lovely perspective and moving figures. Note the tone values which are really strong in places, such as the arch on the right and the slanting shadow on the projecting building on the left. Observe the stone paving of the road with the joints giving perspective and depth in the same way as **Figure 41**. Also note the strong shadows of the buildings, balconies and eaves which give brilliance to the sunlit walls.

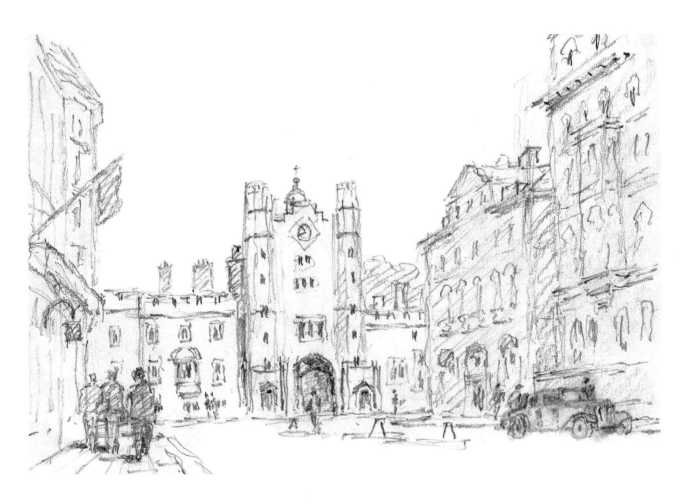

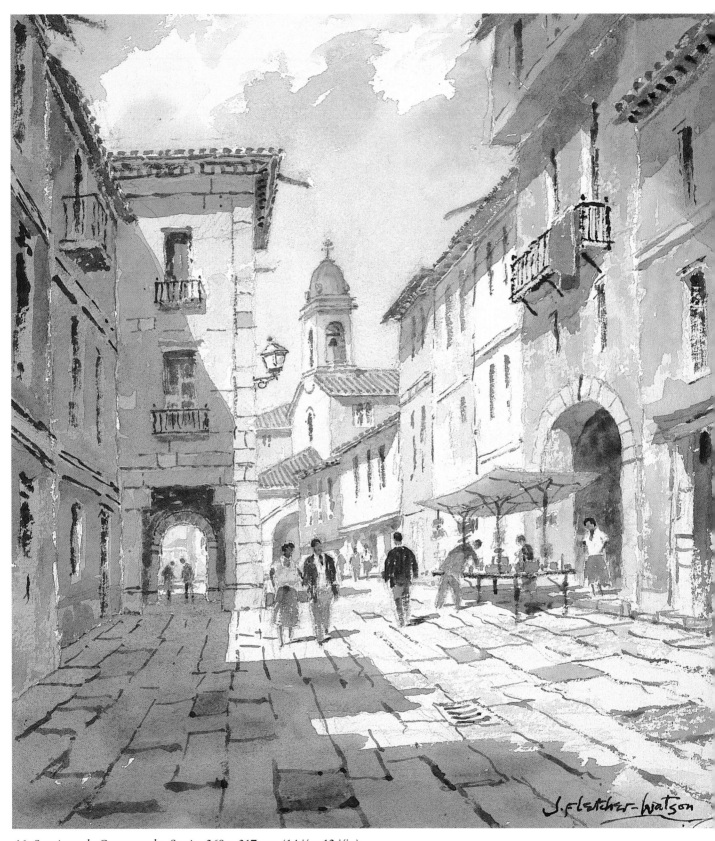

46 *Santiago de Compostela, Spain.* 368 x 317mm (14 ½ x 12 ½in)

This chapter concludes with two views illustrating simple country town architecture which I don't think you would find difficult to paint.

Figure 47, *A backyard, Lavenham*, is an example of how if you bother to go through an archway leading off a main street you will often be rewarded with a lovely unspoilt view of old roofs, chimneys, windows and rough old doors which have not been brought up to date. This little view is quite simple and very sketchable but needed a little knowledge about perspective.

The lines of the walls, shed gutters and the eaves of the gable on the left are all going in the rough direction of the head of the man standing in the archway.

Figure 48, a rather more exciting backyard in Suffolk was similarly discovered by turning off the main street down a narrow alleyway to find it opened out into a lovely backyard. Here I found a stable and a pony looking out and beautiful unspoilt gables and dormer windows, and mellow old tiled roofs. The trees and church tower were an extra

bonus and contributed to a really superb subject. Note how good the composition is with the strong tone of the trees on the right counter-balanced by the stable and dark shadows on the left.

47 *A backyard, Lavenham.* 158 x 173mm (6 ¼ x 8 ¾in)

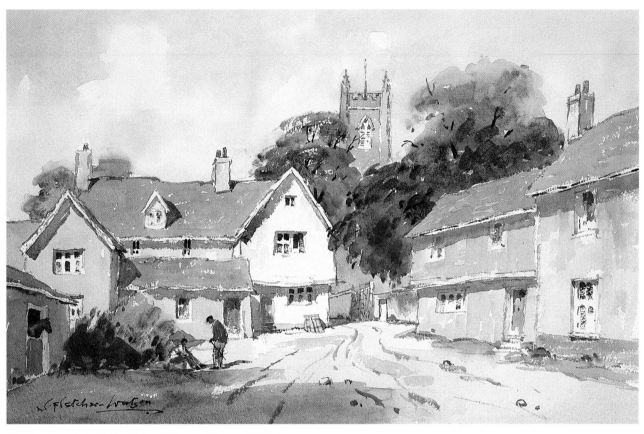

48 *Backyard, Suffolk*. 318 x 470mm (12 ½ x 18 ½in)

TIPS AND TECHNIQUES

- Tone values will invariably play a crucial part in the depiction of buildings in an urban setting, so remember to plan the gradation of tones throughout the picture right from the beginning

- Lines from stone paving joints will help to focus the perspective and depth of a picture

- Having found a subject, remember to research every angle to paint it from – I often walk round my subject before selecting the best viewpoint

- When working with sun and shadows on a large subject, the light will change very quickly, so it is a good idea to indicate the shadows lightly in pencil before starting to paint

CHAPTER 7
M O U N T A I N S

Mountain scenery with castle; bridges; lochs; and low clouds

Mountain scenery has always had an enormous appeal for me, mainly I suppose because it is usually in completely unspoilt country untouched by the hand of man. *Kilchurn Castle, Loch Awe, Scotland* (**Figure 49**) is a mountain view of great beauty. This of course contradicts what I have just said as it does include the hand of man in the form of the castle!

Directly I came across this subject I knew it was a must for a picture, but I was aware that I had to be careful not to produce a chocolate box painting. The composition was perfect once I had moved the castle slightly to the right. Then everything fell into place – loch, mountains, trees, castle and rocks.

After drawing the castle carefully and sketching in the rest of the picture lightly with a 2B pencil, I started the painting process.

1) The sky consisted of French Ultramarine and Burnt Umber for the grey clouds, with a touch of Raw Sienna added for the lower clouds. White cloud shapes were left on the white paper and Cobalt Blue painted in as necessary, with the sky wash damp, but not too wet.

2) The mountains came next, with Cobalt Blue and Light Red used for the distant ones and Burnt Sienna and Burnt Umber added for the nearer ones.

3) The foreground and middle distance grass was then painted with Raw Sienna and French Ultramarine using a light tone for the grass in sunlight before cloud shadows were added.

4) The castle was the next stage, painted in an all-over light grey wash using Cobalt Blue,

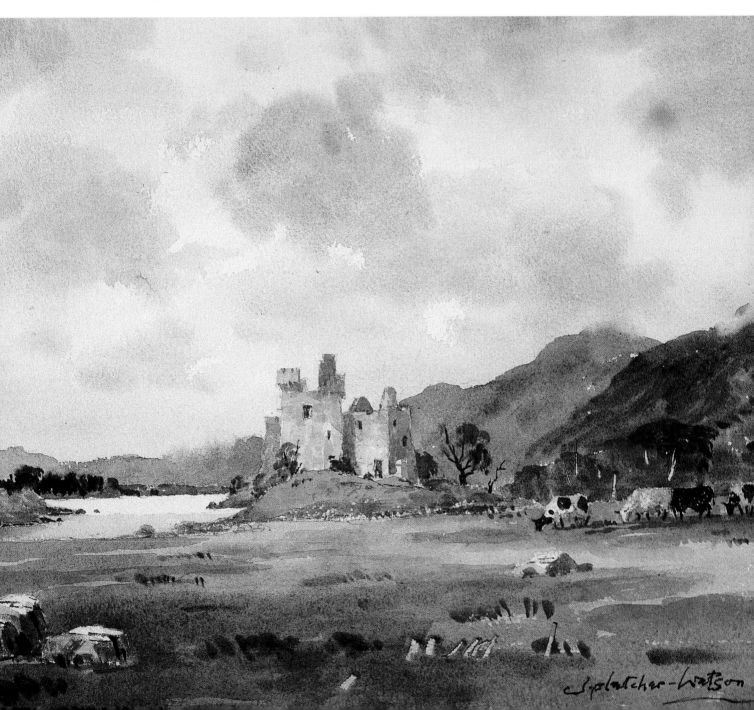

Light Red and Raw Sienna. The shadows on the building were a stiffer, darker mixture of the same colours, using less water and more paint with a small No. 5 brush.

5) The rocks and castle were then painted with suitable dark grey shadows with Burnt Umber used for the cows on the right-hand side.

6) The various tree groups were composed of mixtures of Raw Sienna, Winsor Blue and Burnt Umber. The cloud shadows on the grassed areas were the same mixture as for the trees, using mainly Raw Sienna. A few foreground grass tufts were put in with stronger mixes of the same colour. Rather dry brushwork and a penknife blade gave a few light grass clumps.

49 *Kilchurn Castle, Loch Awe, Scotland.* 318 x 476mm (12 ½ x 18 ¾in)

The enlargement of the castle in **Figure 50** shows the treatment of architectural detail, the wall colouring and local trees. The colours used for the whole picture were Raw Sienna, Burnt Sienna, Burnt Umber, Light Red, Cobalt Blue, French Ultramarine and Winsor Blue. You can paint almost anything with these seven colours.

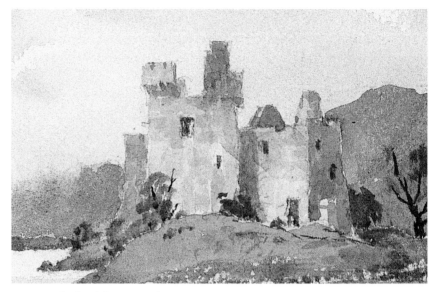

50 Detail of Kilchurn Castle

Figure 51 shows how greatly enhanced a subject can be with the addition of a mountain range. The bridge with the half-dry river bed and trees made a good picture, but the grey-blue background mountain range gives depth and grandeur. This is also an example of mountains on a sunny day with no low cloud to break the horizon. Note the cypress tree on the left which is a lovely vertical foil to the horizontal bridge.

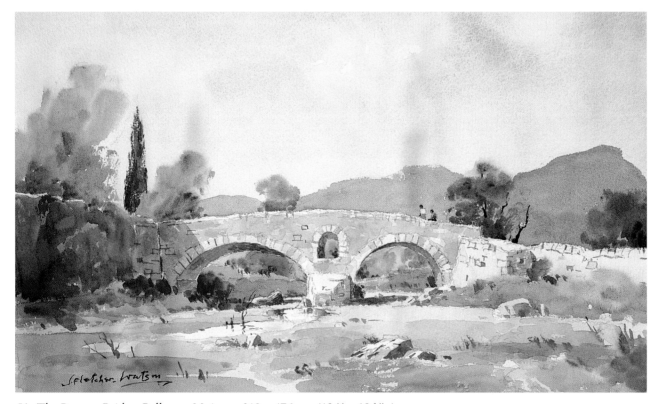

51 *The Roman Bridge, Pollensa, Majorca.* 318 x 476mm (12 ½ x 18 ¾in)

Another good example of a
background mountain range
is shown below in **Figure 52**,
Regello hill village, Tuscany.
Again the picture subject is
delightful, with the central
track leading towards the
cypress trees and little cluster
of houses with their terracotta
roofs in the middle distance
and the umbrella tree on the
right, but the distant mountain
gives that extra quality which
is so valuable.

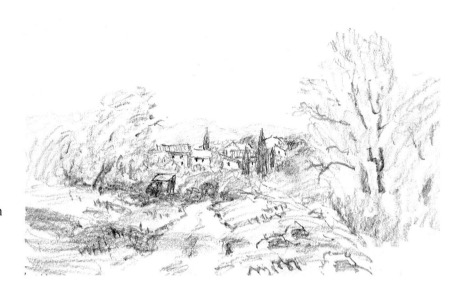

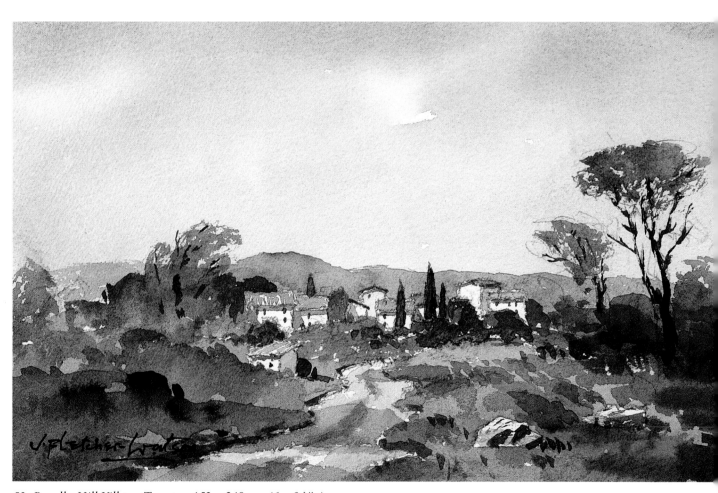

52 *Regello Hill Village, Tuscany.* 152 x 248mm (6 x 9 ¾in)

Up to this point we have concentrated on distant mountains; now let us get a little closer to them. **Figure 53**, *Fleetwith Pike, Cumbria,* shows a mountain track leading to Buttermere Lake, which is just out of sight. The dramatic mountain, Fleetwith Pike, stands up grandly with low cloud just touching its peak. The foreground track is invaluable to this subject, leading the eye into the picture, and the dark tree on the left and dark bush to the right are important features, helping to make a strong composition. The colour scheme consists virtually of blue-greys and yellow-greens which gives a very harmonious whole.

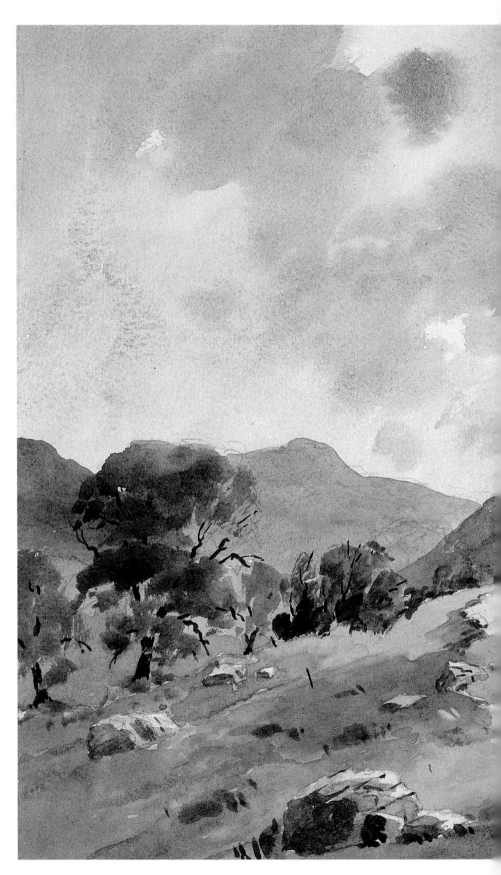

53 *Fleetwith Pike, Cumbria.* 317 x 476mm (12 ½ x 18 ¾in)

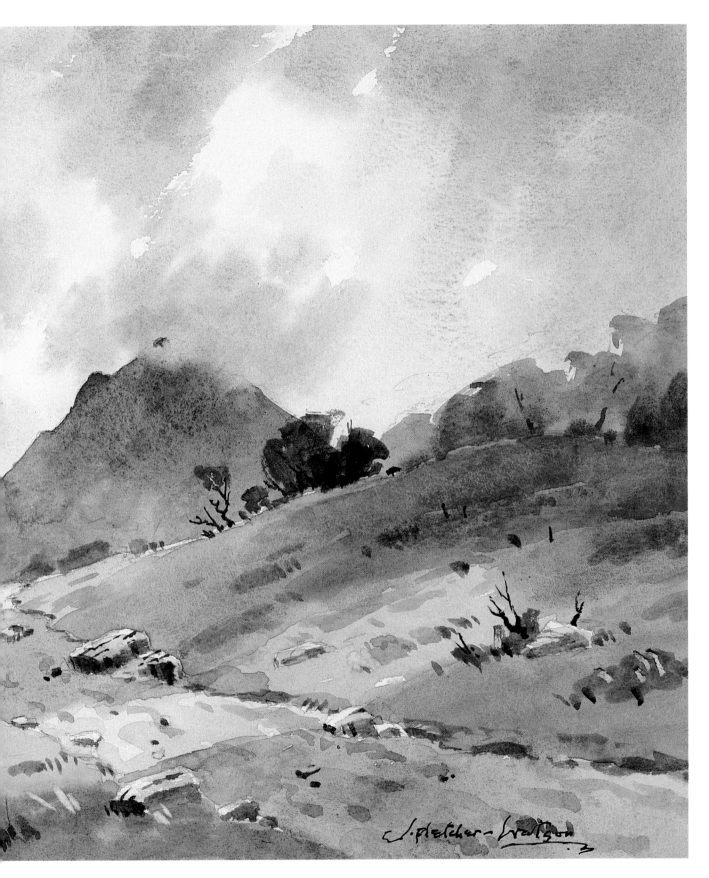

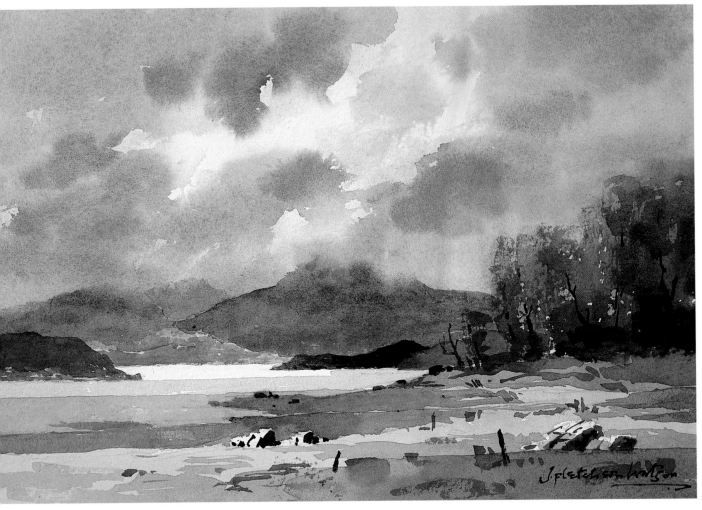

54 *Loch Shieldaig, Scotland.* 235 x 362mm (9 ¼ x 14 ¼in)

Moving now to **Figure 54,** *Loch Shieldaig, Scotland,* we have a lovely composition of mountains, trees and a loch. This is a very exciting subject and on this day of broken cloud and sun it was full of the most amazing colours. Autumn is the time of year which always shows Scottish mountain scenery at its best.

Some of the gravelly foreshore of the loch was positively purple in colour and to paint this I used a mixture of Rose Madder and French Ultramarine. Two of the island promontories in deep cloud shadow were painted a very dark brown using Burnt Umber and French Ultramarine. On the far side of the water there is a low piece of yellow land for which I used pure Raw Umber. This was most striking amongst the dark background mountain as it was lit up by a gleam of sunlight.

Mixtures of Raw Sienna and Winsor Blue were used for the foreground areas, and Burnt Umber and Winsor Blue for the right-hand woods. The mountain itself was mostly painted with Burnt Umber and French Ultramarine.

Good composition is particularly important in relation to mountain scenes, and you will often find dramatic recession in the varying shapes of near and distant mountains. There are several more examples of mountain scenes featured in the following chapter.

TIPS AND TECHNIQUES

- Mountains scenes offer great inspiration to the painter

- A mountain range can either be a subject in itself, or give a dramatic background to another subject

- Remember to avoid creating hard edges when painting distant mountains. They will look more effective with softer, slightly diffused outlines

CHAPTER 8
WATER & REFLECTIONS

Cotswold rivers; Scottish loch; Cumbrian lake;
Italian waterway; Cumbrian waterfall

First of all I would like to show you the rule governing reflections which can be seen in calm water such as in a lake or a slow-moving river. **Figure 55,** *Snow on the Windrush River,* shows a block of trees in the centre, some way back from the water's edge and on the right is a group of trees quite near the water. Water in snow scenes can look quite dark.

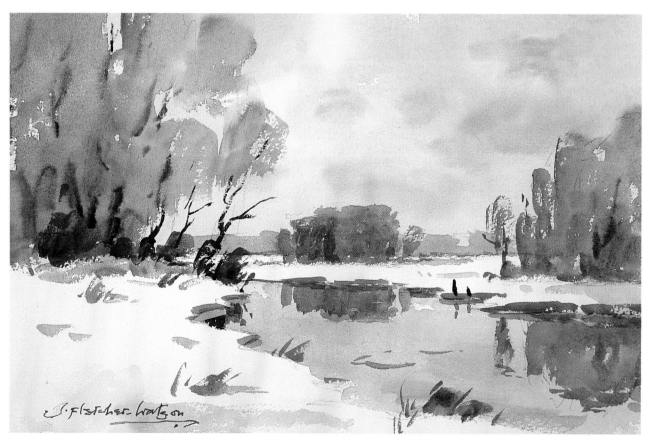

55 *Snow on the Windrush River.* 235 x 362mm (9 ¼ x 14 ¼in)

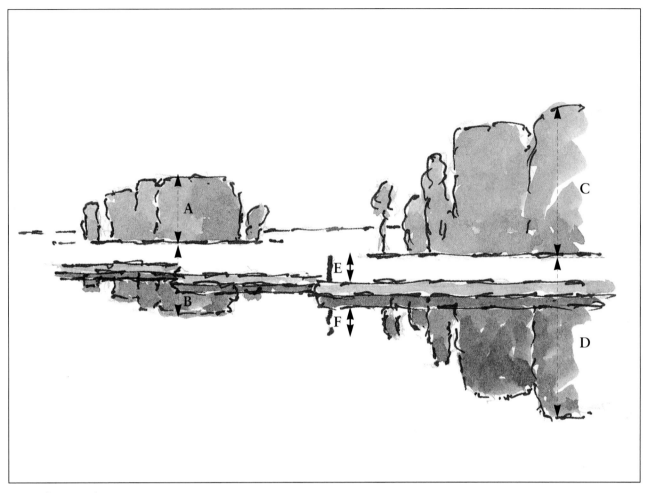

56 Reflections diagram

The diagram in **Figure 56** shows you how to measure the depth of the tree reflection in the water. The height of the trees at A is measured vertically downwards as shown at B. You will see that the measurement is taken from a point slightly below the base of the trees, so as to allow for the ground thickness which is the equivalent of the river bank thickness. The result is that far less of the trees will show reflected in the water than can be seen above ground.

If we look at the trees at C, we find that the depth of reflection at D is much greater owing to the trees being nearer the river bank. And again the post at E reflects its full height at F, because it is right on the edge of the water.

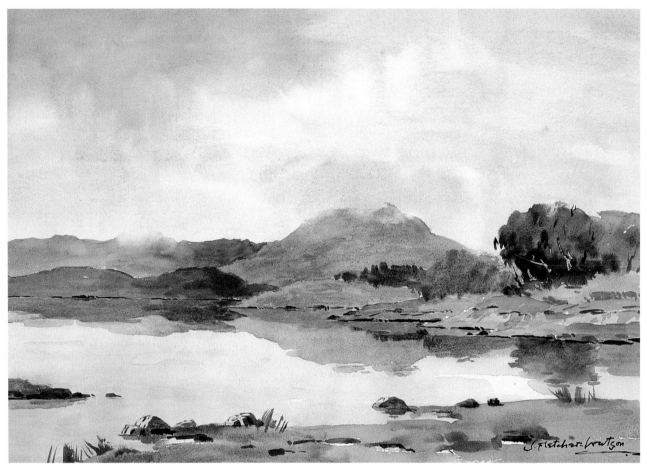

57 *Loch Etive, Scotland*. 330 x 482mm (13 x 19in)

Figure 57, *Loch Etive, Scotland*, shows another example of reflections. The reflection of the mountain in the water is only about one-third of its full height, because of its great distance from the water's edge. The brown trees on the right are reflecting about two-thirds their height in the water as they are only a short distance from the bank.

When choosing a subject with water, I always look out particularly for features on the far side of the water that give a reflection. Even a tree stump or bush is better than nothing, as it will help to give the water a more liquid appearance. Reflections of the sky can also contribute to this effect, especially if there are several patches of blue.

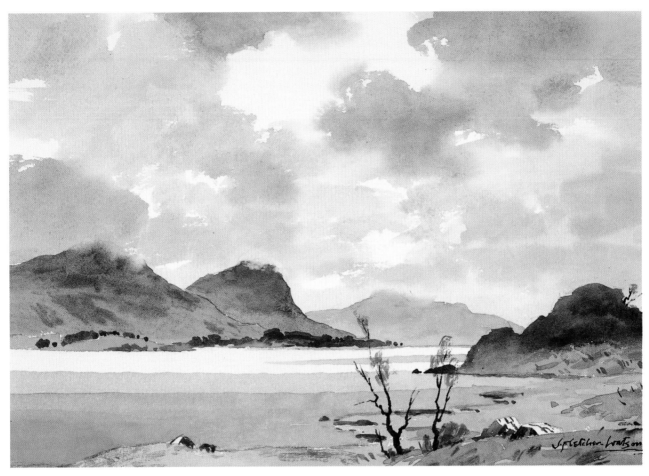

58 *Bassenthwaite, Cumbria.* 318 x 476mm (12 ½ x 18 ¾in)

Figure 58, *Bassenthwaite, Cumbria*, is a lovely lakeland subject with a good cloudy sky on a windy day. The wind ruffled the water and there were therefore no reflections. I used washes of watered-down Payne's Gray, starting with one light wash and, after it had dried, I applied a slightly darker wash over it. The white of the paper was left for the distant part of the water where the sun caught it at an oblique angle. This is simple to do and very effective.

Water reflecting boats and buildings is always an interesting subject and **Figure 59** shows the lovely Italian town of Chioggia near Venice. The sky, buildings and boats were all painted first and then I could think about the water. It had a slight movement and the reflections were therefore painted with wavy edges. The gondola on the left side was painted last, as this was strong in tone value and fairly close to me.

I was careful not to overdo the detail both for the actual buildings and boats and their reflections, otherwise the whole picture would have become fussy and restless.

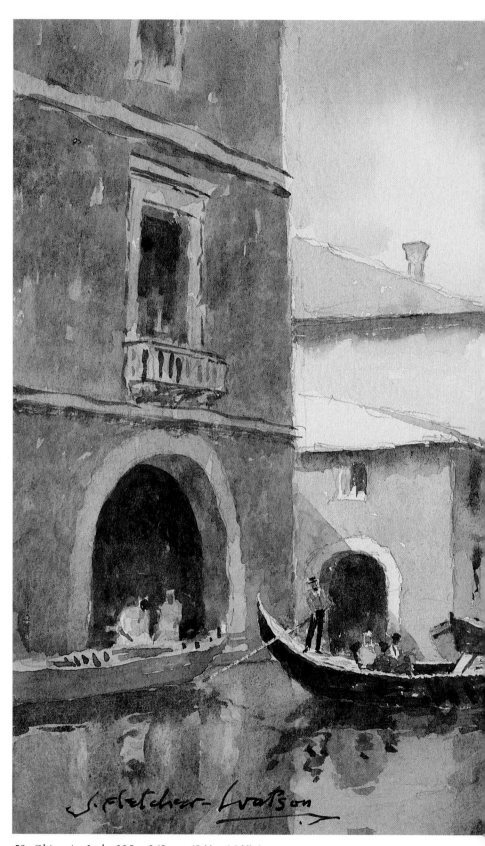

59 *Chioggia, Italy.* 235 x 362mm (9 ¼ x 14 ¼in)

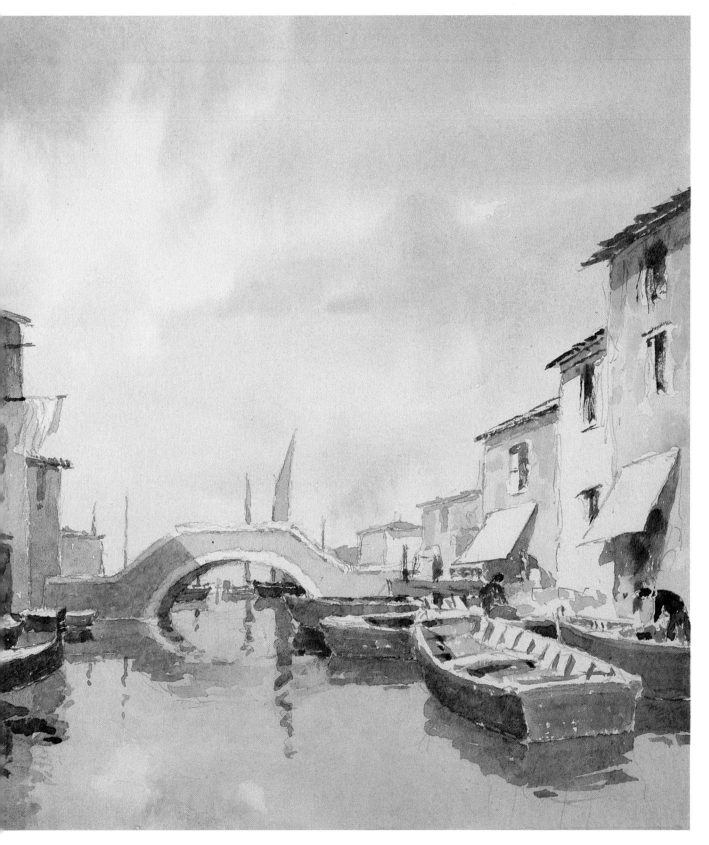

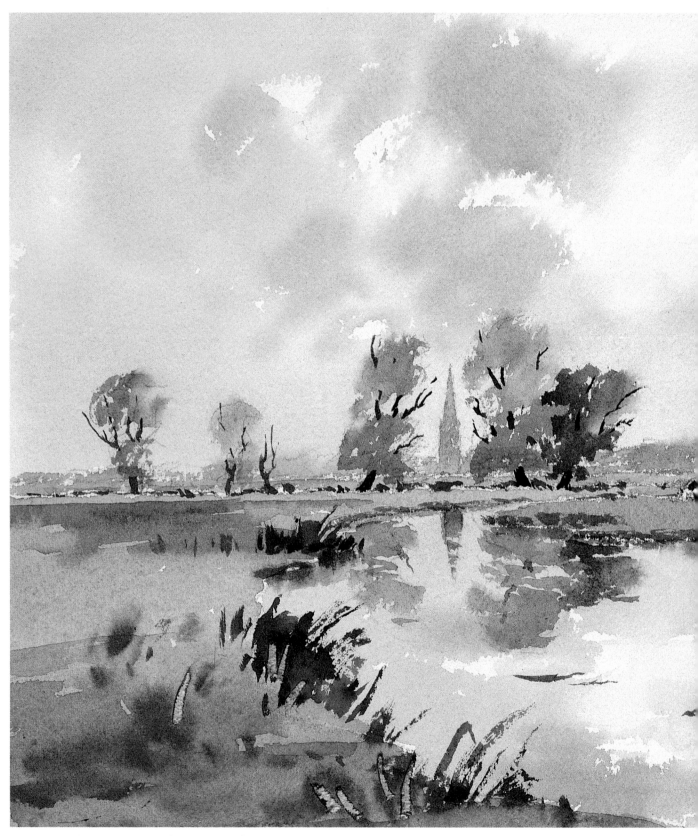

60 *Windrush River, near Burford*. 235 x 362mm (9 ¼ x 14 ¼in)

Figure 60, *Windrush River, near Burford*, was painted from a position where the river was fairly wide and the reflections included not only the church spire and trees, but also a considerable amount of sky. A good cloudy, sunny sky with pronounced blue areas is always an attractive feature when seen in a water reflection. I moved up and down the bank looking for a good wide area of water in order to arrive at a suitable vantage point for achieving this expanse of sky.

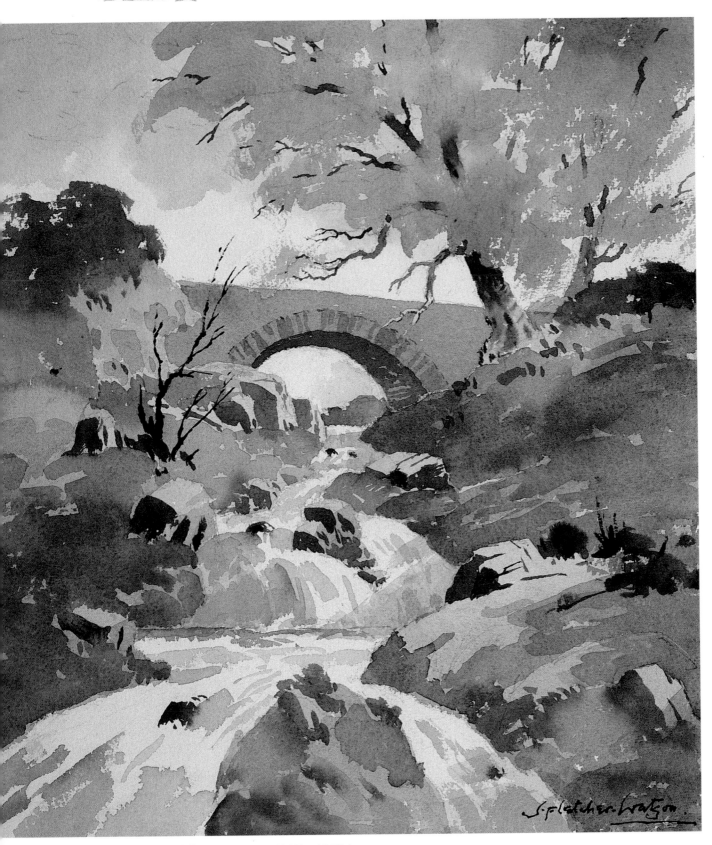

61 *Cumbrian waterfall.* 362 x 311mm (14 ¼ x 12 ¼in)

Figure 61, *Cumbrian waterfall*, is a really good example of dealing with fast-moving water. I found this exciting little view with a stone footbridge quite by chance in the Borrowdale district of the Lakes. At first it seemed a daunting subject to paint, but once I had got it all carefully drawn in pencil, the painting work was less difficult.

After laying in the blue sky, I used cool grey-green mixtures with Raw Sienna, Burnt Umber, Cobalt Blue and a touch of Winsor Blue for the bridge, trees and banks and then the rocks. Next came the water which was mainly light grey, using mixtures of Cobalt Blue, Light Red and touches of Raw Sienna. The smooth horizontal surfaces were left white while the racing sloping parts were streaky grey. It all came together finally with some really dark touches for the rock shadows and the small tufts of grass.

I would like you to note the composition of this painting, which is unusual. The focal point is the bridge, which is positioned high up in the picture. The arrangement of rocks and small waterfalls is carefully planned to give an excellent balance.

TIPS AND TECHNIQUES

- Remember the rule governing reflections in calm water – the reflection of any object will always be measured from its base, even if this is hidden from view

- When looking for a subject with water, look for elements that will give an effective reflection that will enhance the quality of water

- A water reflection will benefit from a cloudy, sunny sky with definite blue areas

- Do not overdo painted detail for subjects and their reflections

CHAPTER 9
LANDSCAPES

*Cumbria; Cotswold valley
in snow; Norfolk; Scottish loch with cottage*

This chapter tries to show how you can go far beyond mere topographical representation for a landscape painting. I would like to remind readers that we have all inherited a wonderful watercolour tradition handed on to us by Turner, Cotman, De Wint, Constable and later painters such as Winslow Homer and Sargent. Of course there are others too numerous to mention and this tradition is still developing.

Everything we have been talking about in preceding chapters, including light coming from the sky, colour, shapes and composition come together in a magical landscape picture before our eyes. Having dealt with the techniques for the individual items in a landscape, such as skies, trees, buildings and mountains, I will now consider the landscape as a whole. In

order to make the whole picture satisfactory, it is important to suppress unnecessary detail and to achieve a balance between colour, tone and composition so that all these things contribute rather than compete with one another.

I have chosen **Figure 62**, *Crummock Water, Cumbria,* as an example which I feel meets this requirement. The picture was painted on a most beautiful day with strong cloud formations and bright sunlight. Burnt Umber and French Ultramarine were the only colours used for the sky. This demonstrates what a variety of tones can be obtained with only two colours.

The composition of this picture gives a happy balance with the dark brown mountain on the left and the slightly larger mass of dark trees on the right. These two masses were

purposely made different sizes. The focal point is the lake and distant grey-blue mountain, and I used a Cobalt Blue and Light Red mixture for the latter. The foreground is brought to life with cloud shadows and rocks judiciously placed.

This all sounds so simple when expressed in a few words, but there is a lifetime of experience behind it. I am hoping to give you some short cuts so that you can produce an exciting picture after a comparatively brief period of practice.

Of course, finding a subject is the secret of good landscape painting and you must develop the knack of transferring a subject immediately on sight onto a piece of watercolour paper. This must be done in your mind's eye as you look at a view. Try practising this every yard of the way on your next country walk. And don't

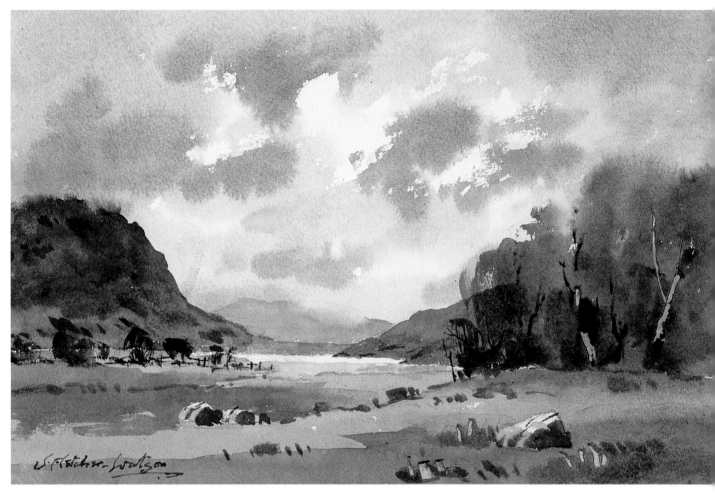

62 *Crummock Water, Cumbria.* 235 x 362mm (9 ¼ x 14 ¼in)

forget artist's licence, which means being able to move observed objects slightly or even leave them out altogether. This is quite permissible within reason but don't take it to extremes.

Try not to choose too complicated a subject to start with as you could find this an uphill struggle. Instead choose a very simple subject which will lead to success.

I thought it important in **Figure 63**, *Fall of snow, Windrush Valley*, to show a landscape where the focal point is not immediately apparent. Although it is not always essential to have a strong focal point, in most cases it is helpful. Here your eye probably goes first to the half-open gate and the sheep. But it soon carries on to the small central wood and the farmhouse beyond on the left of the picture. The cloudy, sunny day breaks up the monotony of the white snow-covered land with well-placed cloud shadows. I have mentioned selecting a simple subject and this is one example. It is, however, not such a perfectly balanced subject as **Figure 62**.

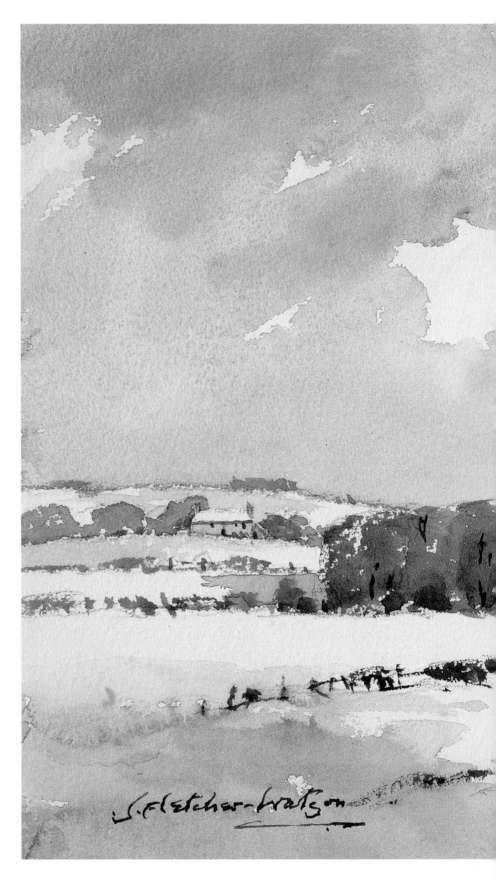

63 *Fall of snow, Windrush Valley.*
235 x 362mm (9 ¼ x 14 ¼in)

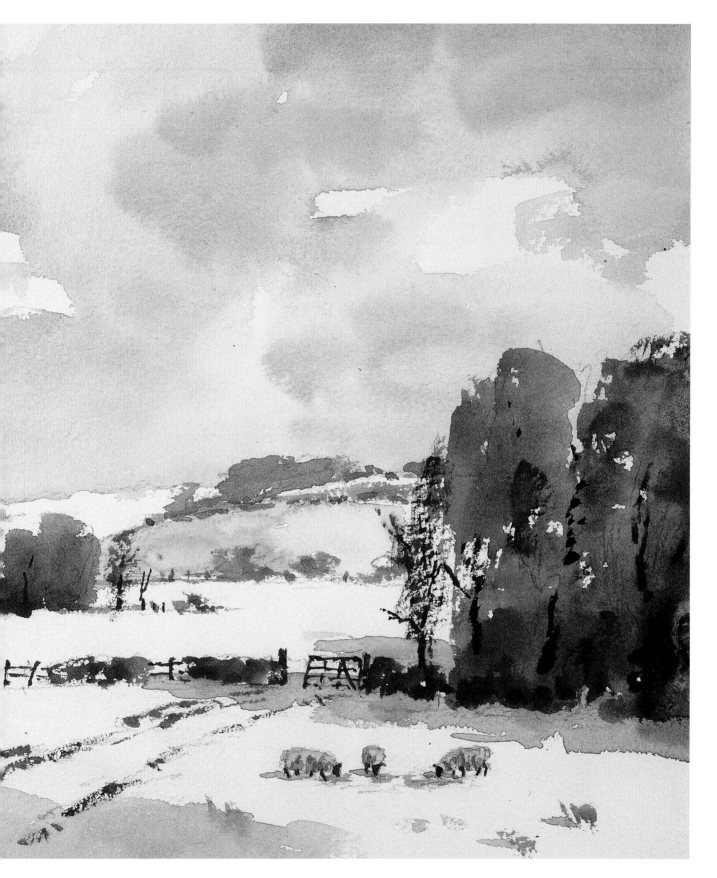

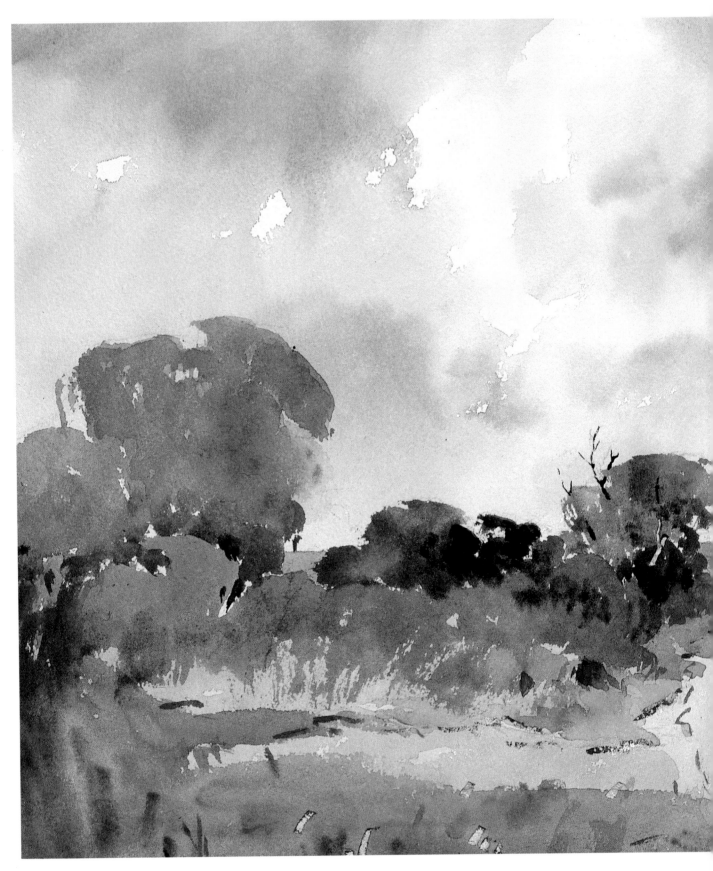

Figure 64, *Above Brancaster, Norfolk*, is an autumn picture which could be said to typify the English landscape. Many people would pass this by seeing nothing worth painting, but that is where the experienced eye of the artist is useful. If it had not been for the sun and cloud and tree shadows falling across the road, it would have had little interest. But the autumn colouring and the particularly attractive light, which often occurs in Norfolk, made this an irresistible subject which I longed to put on paper.

The various trees and grassed areas were painted with mixtures of Raw Sienna, Burnt Sienna and Winsor Blue. The rather dark, shadowy trees were created with Burnt Umber and Winsor Blue, and Payne's Gray was added for some of the extra-dark foliage.

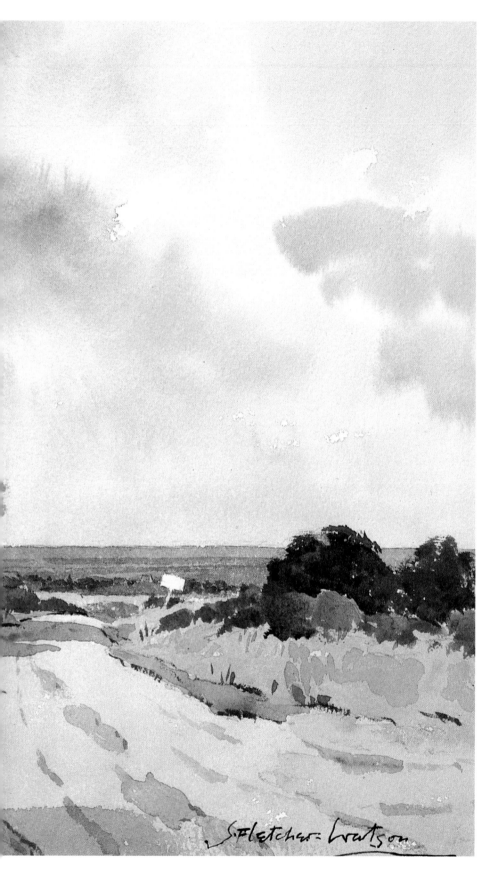

64 *Above Brancaster, Norfolk*.
318 x 476mm (12 ½ x 18 ¾in)

Figure 65, *Runham Mill, Norfolk*, shows a windmill in a landscape. This is a rare subject to find, but fortunately there are windmill societies which protect and maintain a few examples, most of which are the larger type of corn mill.

This is an ideal subject for those of us who wish to paint a picture in the tradition of pure landscape. Here we have a big sky with a low horizon, giving a great sense of distance and a fascinating vertical feature in the form of a marsh-draining mill built of brick and timber. There is a wind blowing which is indicated here by the bent foreground grasses and this adds to the atmosphere of the scene.

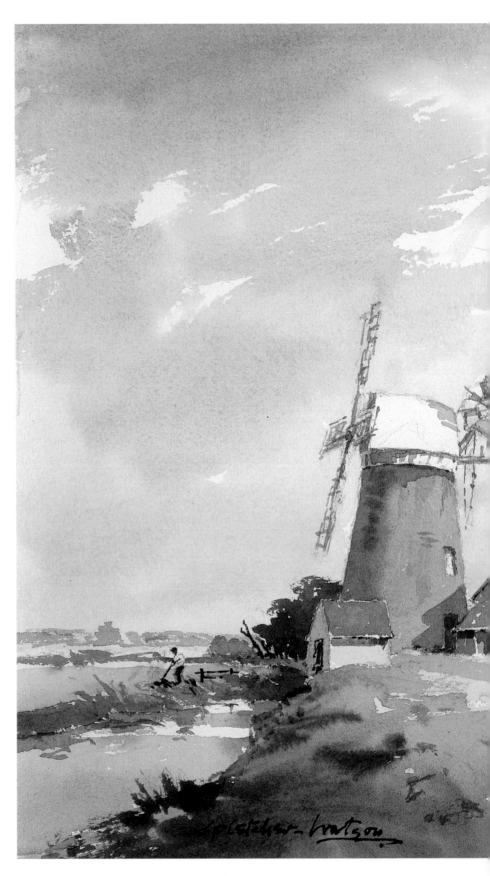

65 *Runham Mill, Norfolk.*
318 x 476mm (12 ½ x 18 ¾in)

Raw Sienna

Light Red

French Ultramarine

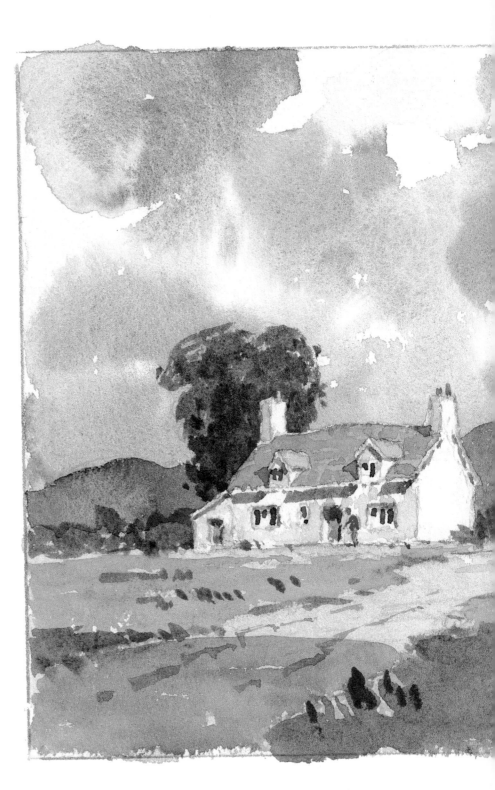

66 *Cottage by a Scottish loch*. 146 x 203mm (5 ¾ x 8in)

Figure 66, *Cottage by a Scottish loch*, is a picture painted with only three colours, Raw Sienna, Light Red and French Ultramarine (although almost any yellow, red and blue would be suitable). This is an extremely good exercise to give yourself as it will make you concentrate on the *tone values* as much as the colour. In this case I used Saunders-Waterford 300lb paper which has a slightly cream colour and absorbs washes extremely well. The painting process was as outlined below.

1) As it was a fairly small picture and I did not require a thick line, I used a B pencil. The cottage was drawn first, positioned slightly to the left, followed by the line of the loch and background mountain. Next the small tree behind the cottage, the large tree to the right and the rough unsurfaced track in the foreground were added.

2) The painting began with the sky, mixing first French Ultramarine with Light Red, giving a rather hard grey and then adding a little Raw Sienna making a softer, warmer colour of grey for the clouds. I first damped the sky area with clear

water and then applied the grey wash, leaving suitable white spaces. I brought the wash right down to the foot of the mountain and carefully painted round the white cottage.

Next I dropped in the blue sky patches, with the paper still half-damp, using pure French Ultramarine in varying strengths. Finally I mixed a slightly darker grey with the three colours and over-painted some of the grey clouds which brought the whole sky to life.

3) The mountain was then painted with a mixture of French Ultramarine and just a touch of Light Red. This gave it a slightly purple colour, but I added some neat blue near the top of the high mountain. I used the trick of the low cloud over the mountain top as previously described.

4) Once everything was dry, I tackled the cottage. The roof was done first using French Ultramarine with a little Light Red and Raw Sienna added. I made it a warm grey so it was distinct from the mountain. I kept playing with the three colours until it was right. Then came the windows and doors, using stiffer mixes to give a darker tone. Also the shadows under the roof eaves and door openings were put in.

5) Then I worked on the trees and shrubs. The tree behind the cottage was the darkest green, a stiff mixture of French Ultramarine and Raw Sienna. The big tree on the right was painted with the same two colours but the yellow was made more dominant. I dropped in a little neat Light Red near the top to give the autumn colouring which was starting to show. The very dark shadow on the trunk of the big tree was a strong mixture of all three colours.

6) The foreground grass was painted with a mixture of Raw Sienna and a little French Ultramarine. The shadows were a stronger mixture of the same two colours, but for the track shadow I used French Ultramarine with a touch of Light Red. The dark rock shadows were painted with all three colours using a very stiff mixture which produced an almost black colour required.

I strongly advise any of my painting friends who have never tried this 'three colour only' system to experiment with this idea. It does teach you a great deal about composition, tone values and generally building up a harmonious picture.

TIPS AND TECHNIQUES

- Avoid unnecessary detail in a landscape composition in order to achieve a pleasing balance between all the different elements

- Remember to define a focal point in a landscape to give the painting the correct balance

- When selecting a subject, it can be effective to first translate it onto watercolour paper in your mind

- Avoid over-complicated subjects when starting to paint landscapes, and even when you are more experienced a simple subject can often give the best results

- Landscapes can be painted using a three-colour system of French Ultramarine, Light Red and Raw Sienna. This simple system helps you to develop skills in composition, tone values and the balancing of a painting

CHAPTER 10

SPECIFIC SUBJECTS

The Forum, Rome; Regello, Tuscany; a cloister, Spain; church interior,
Oxfordshire; stormy weather, Cumbria; and a Spanish street on toned paper

This chapter gives illustrations of slightly more advanced subjects which are fun to tackle when you have reached a greater level of confidence.

Figure 67, *The Forum, Rome*, is the most splendid architectural subject imaginable. The Forum is like a gigantic outdoor museum of Roman remains, and the ground is strewn with old pieces of cornice or columns. There were many paintable views, but I eventually settled on the one shown here as the distribution of trees was excellent in showing up portions of buildings and, most importantly, I could sit in a bit of shade as it was a very hot day. Thankfully my wife, Gill, produced a cool drink at suitable moments!

A subject of this level of complexity must be considered very carefully before you start drawing and painting it, or the result could be a restless, unsatisfactory picture. I think I managed to avoid this successfully by the careful composition, which balances well, and with the dark trees and bushes, which are an immense help in making architectural features stand out. This is especially the case with the central group of columns through which the dark tree can clearly be seen.

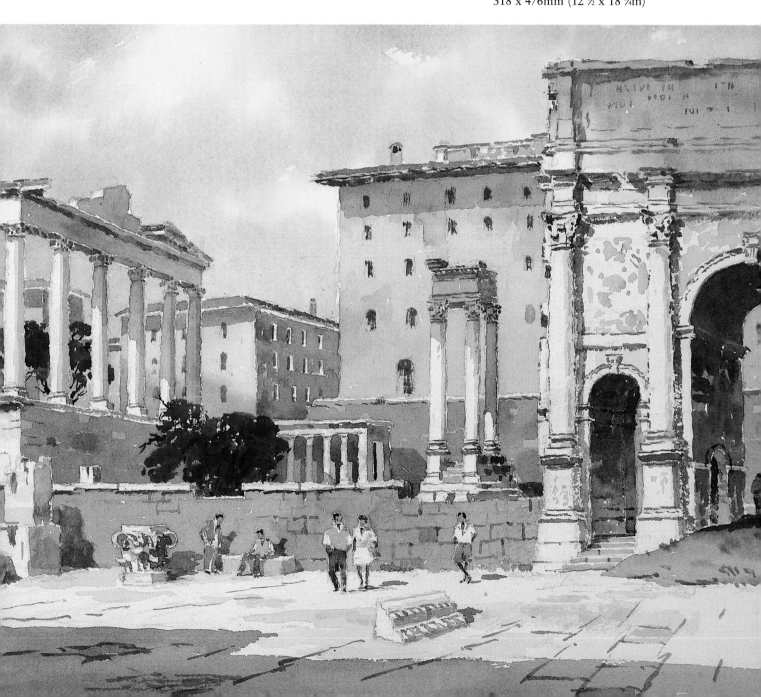

67 *The Forum, Rome.*
318 x 476mm (12 ½ x 18 ¾in)

68 Pencil drawing done on the spot

Figure 68 shows my pencil sketch which was done on the spot. I felt that I could make a much better job of a watercolour if I painted it in my studio at home, and I made a note or two on the sketch about colours, etc. It took about one and a quarter hours to draw *in situ*. The actual watercolour at home took two hours to draw and about three hours to paint. If you look closely at the sketch, you will see that the architectural details of cornices, capitals and columns are not at all precisely executed, but just painted quickly and suggestively. I did not use a very small brush, but a No. 8 with a really good point.

I used Cobalt Blue for the sky; Raw Sienna, Burnt Sienna, Burnt Umber and Cobalt Blue for the buildings and shadows; and Winsor Blue and Burnt Sienna for the trees.

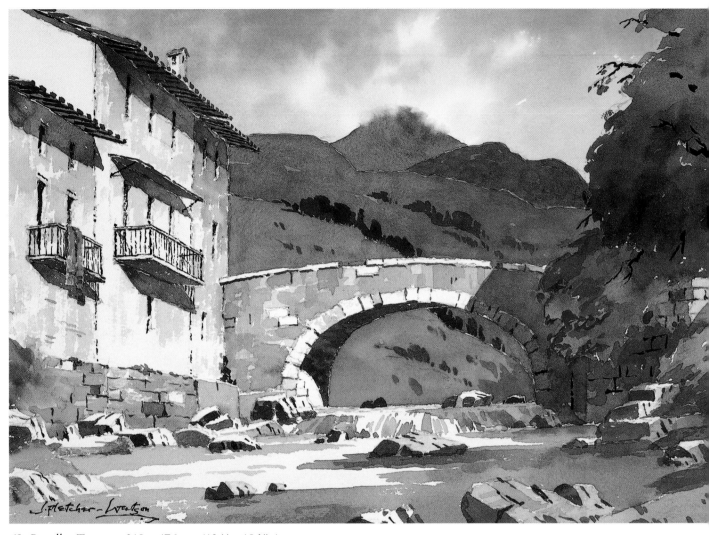

69 *Regello, Tuscany.* 318 x 476mm (12 ½ x 18 ¾in)

Figure 69, *Regello, Tuscany,* is a painting of a delightful little hill village where Gill and I stayed for a week discovering many good subjects. I had to scramble down a narrow track and over some rocks to find this view. What makes this such a good subject? Well, the angle of the sun for one thing, though I had to wait for it to move where I wanted it. The glancing shadow from the trees onto the bridge was worth waiting for and also the shadows on the water. The rocks in the stream were valuable features although I did need to adjust their positions slightly. The houses had good deep shadows under their eaves and balconies. This perfect composition with a mountain background made the whole scene a dream picture. I will not elaborate further, as the composition really speaks for itself.

Figure 70 is another extra-special subject – a Gothic cloister. With an interior architectural subject such as this, it always pays to find a vanishing point. In this case, the guidebook held by the man was in approximately the right place. To find this point you draw an imaginary line along, say, the stone flooring joints and the apex of the ceiling arches and the top edge of the low wall on the right, and you will find they all meet at this point. This is called parallel perspective because there is only one vanishing point, rather than two (see **Figures 73a** and **b**). I will explain perspective more fully at the end of this chapter.

Having carefully pencilled in the main features of the pointed arch vaulting and the right-hand arched arcade and the floor lines, I lightly sketched in the two stone figures standing in the furthest arches and the buttresses on the right in the sunlight.

Painting could now start and this consisted of a series of washes of Raw Sienna, Burnt Umber and Cobalt Blue, mixing different colours and tones as required. The result was virtually a monochrome picture, but I am sure you will agree a very attractive one despite the colour limitation.

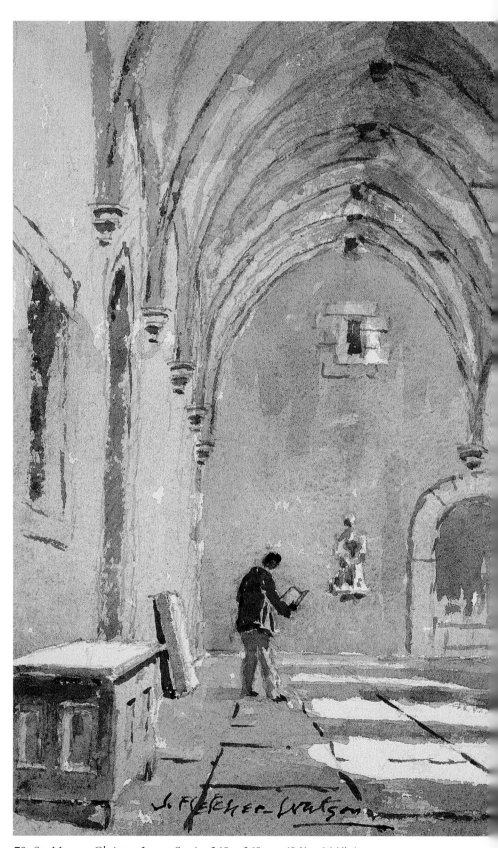

70 *St. Marcos Cloister, Leon, Spain.* 248 x 368mm (9 ¾ x 14 ½in)

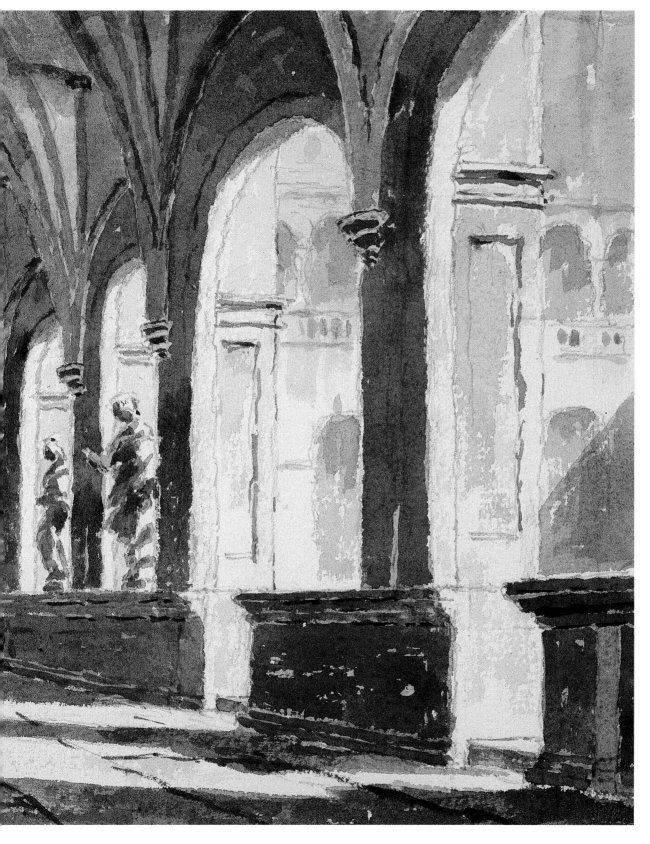

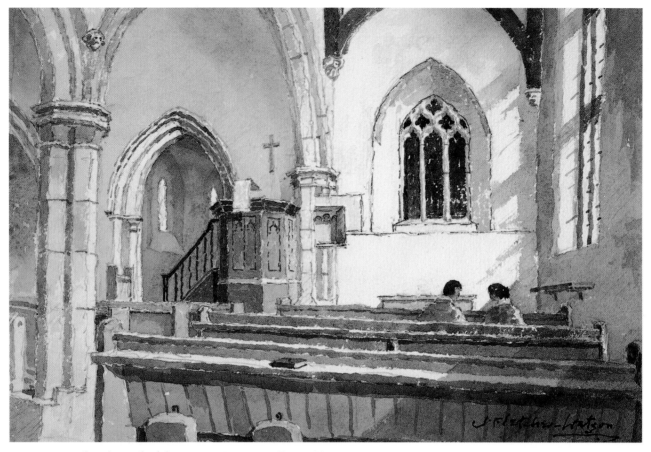

71 *Taynton church, Oxfordshire*. 248 x 368mm (9 ¾ x 14 ½in)

Interiors can be great fun to paint and I show you another in **Figure 71**, *Taynton church, Oxfordshire*. This view was taken from the south aisle, looking east towards the chancel arch by the pulpit. The walls are all whitewashed, hence the bright interior. I only include this to show what delightful subjects country churches can be, so the next time you go sketching and it turns to rain, you could try something like this.

Figure 71a shows another example of a church interior, this time at Windrush.

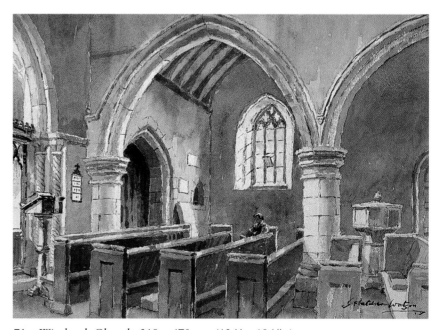

71a *Windrush Church*. 318 x 470mm (12 ½ x 18 ½in)

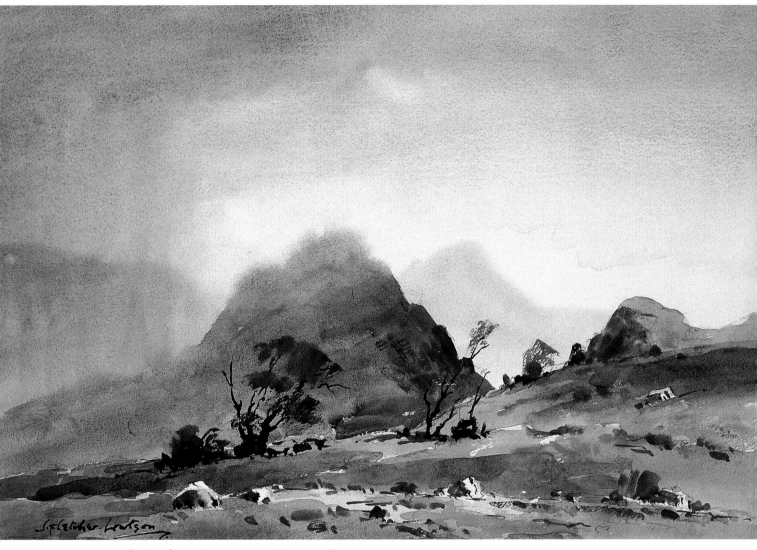

72 *Langstrath, Cumbria.* 318 x 476mm (12 ½ x 18 ¾in)

Figure 72, *Langstrath, Cumbria*, shows Sargents Crag, a well-known peak to Lake District walkers. Gill and I were caught on a walk in a very heavy rain storm, which made the view look both magnificent and dramatic. I had a small sketchbook with me, and using Gill's back as an easel, I sketched this amazing scene in pencil on very wet paper. Back in the studio some time later, my sketch brought it all back to me and I was able to paint a watercolour.

I first put in the stormy sky, allowed it to dry and then by redamping the paper I was able to paint in the blurred mountains, which produced the rainy effect. It was quite an adventure working on it! The wind was blowing from left to right as you can see by the bending trees.

The painting shown in **Figure 73**, *Cordoba, Spain*, used toned paper, because I felt this was suited to the subject which had an abundance of grey-brown stonework on the paving, the walls of the buildings and the monument. I highlighted some of the walls and the monument and paving by using touches of white paint (from a Titanium White watercolour tube by Winsor & Newton). The general effect using white body colour is quite striking. I also used this white paint for a single female figure among the group of pedestrians on the right.

Various toned papers are available – Bockingford do three different tones and De Wint is another make which I use. Turner often used toned paper and sometimes colour washed a sheet of white paper himself using a light grey colour wash.

My picture received a single wash of Cobalt Blue on the sky. The walls of the cathedral on the left and walls of the other buildings were washes of Cobalt Blue, Light Red and Raw Sienna. When mixed, these three can give various tones of stone colour. A little Burnt Sienna was added for some areas.

73 *Cordoba, Spain*. 318 x 476mm (12 ½ x 18 ¾in)

Perspective

At **Figure 73a** I show a diagrammatic illustration of parallel perspective, using the picture of Cordoba shown in **Figure 73**. You will observe the vanishing point at the base of the monument in the centre of the picture.

Figure 73b shows a diagrammatic illustration of angular perspective. I have taken a country cottage as my subject and the eye level when standing is a little below the top of the front door. You can see how helpful it is to have in mind the approximate vanishing point positions.

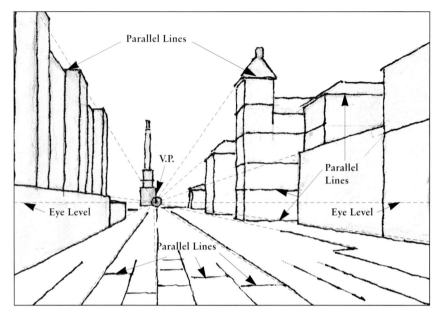

73a Parallel perspective: one vanishing point

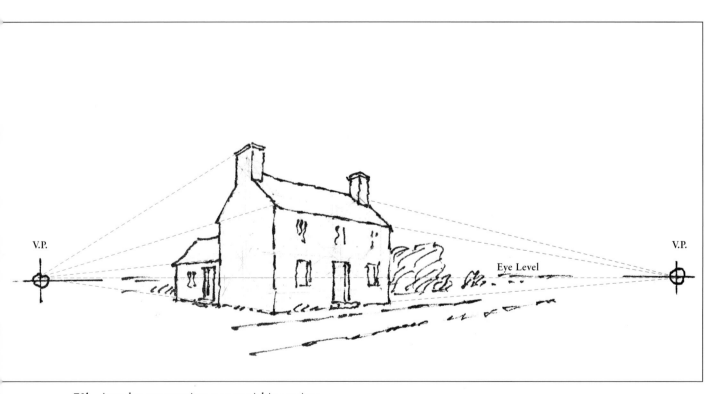

73b Angular perspective: two vanishing points

The picture featured on this page shows an interesting corner of the old part of Norwich. It is another good example of perspective in a scene with buildings.

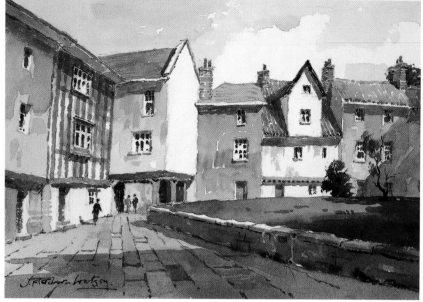

74 *Tombland Alley, Norwich.* 241 x 368mm (9 ½ x 14 ½in)

TIPS AND TECHNIQUES

• Architectural details need not be accurately captured, but can be painted quickly, just capturing an impression

• When painting more complicated subjects, I will often draw my chosen composition on the spot, making notes about the colour and tone and then do the final painting in my studio, where there are fewer distractions

• It will always benefit you to establish the vanishing point when working on an interior architectural subject

• Toned paper can suit certain subjects, and touches of white paint can then be used for highlights

CHAPTER 11
ATTENTION TO DETAIL

Figures; cattle; boats; garden detail

In this chapter I would like to begin with the subject of figures in a landscape setting. Every painter should try to include in his or her training a little life drawing of the nude figure and should practise making a range of studies in a sketchbook of people talking to each other, sitting and especially walking (page 116).

Figure 75, *Santiago de Compostela, Spain*, is a painting of a beautiful city which we have already looked at in Chapter 6. The square shown here has a wonderful flight of steps leading up to the cathedral, and there were many people walking about when I painted this picture.

76 Detail of city square

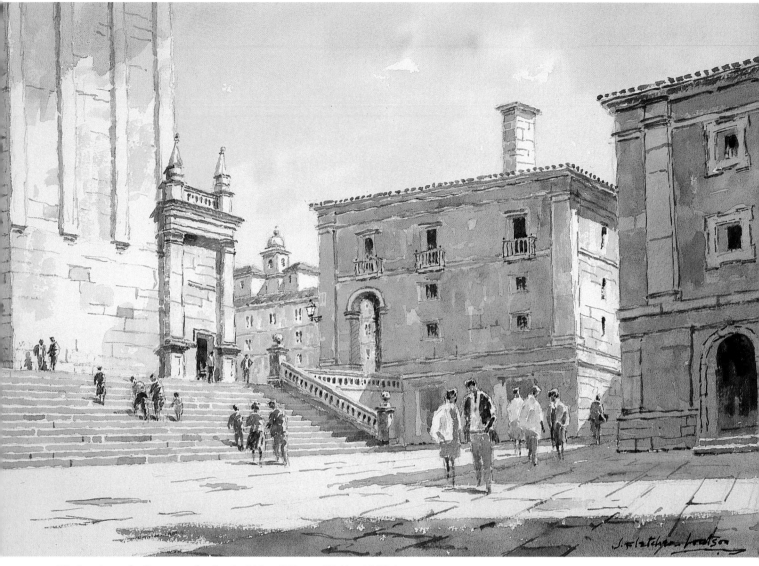

75 *Santiago de Compostela, Spain* 318 x 476mm (12 ½ x 18 ¾in)

I am showing the picture purely to demonstrate the use of figures. The square varied from being quite crowded to having only a few people in it. I decided not to have too many and after careful thought placed them mostly walking within the square. The smaller groups of figures going up the steps were essential to break up the monotony of the lines of steps and to emphasise the distance in the scene. The two near figures in the foreground were important, giving colour and scale to the whole picture. **Figure 76** shows an enlargement of this group of figures – note the light catching the right side of the man's coat.

Figure 77, *Santa Maria della Salute, Venice*, is another picture which is an ambitious subject, where figures and boats play a most important part. The buildings have been played down and treated in a fluid impressionistic way. The central arch feature is painted strongly with some detail, and the buildings at each side are painted with simplified brushwork. The centre gondola with the gondolier in the yellow shirt gives great scale to the whole scene, and as the other boats and figures recede into the background, getting smaller, they add perspective and depth to the picture as well as a nice sense of movement.

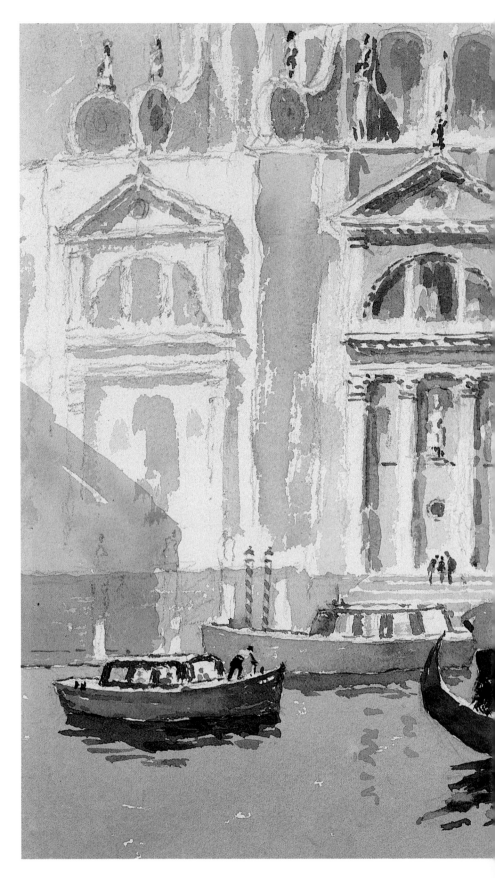

77 *Santa Maria della Salute, Venice.*
318 x 476mm (12 ½ x 18 ¾in)

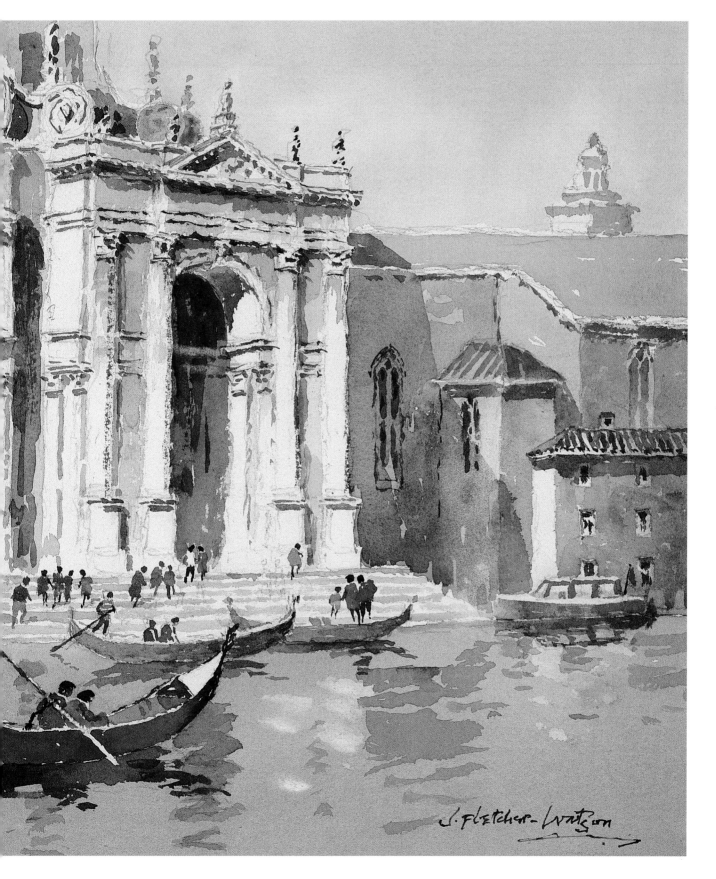

J. Fletcher-Watson

Figure 79, *Burgos, Spain* (opposite), shows one more example of figures in a townscape. The far group is much smaller than the near group which helps create distance and depth. Note that the heads of the figures in the far group are very slightly below the level of the heads of the near group. This is because I was sitting down. The heads of both groups would have been level if I had been standing.

With this picture I used very few pencil guide lines and drew it almost entirely with the brush. You can see this clearly if you look at the stone paving and wall jointing. This method obviates fuss and the over-detailing of architectural subjects.

78 Sketchbook studies

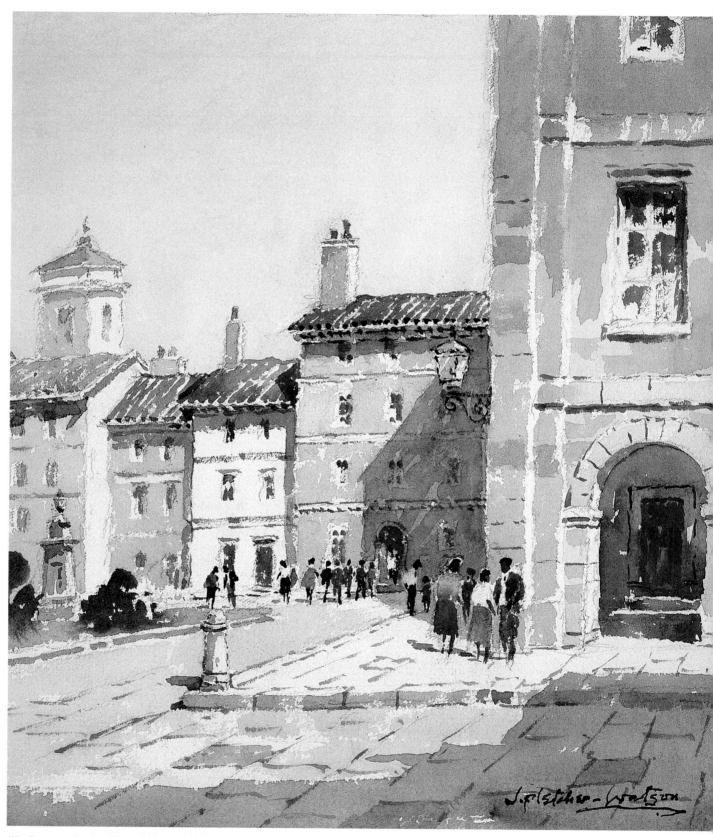

79 *Burgos, Spain.* 337 x 311mm (13 ¼ x 12 ¼in)

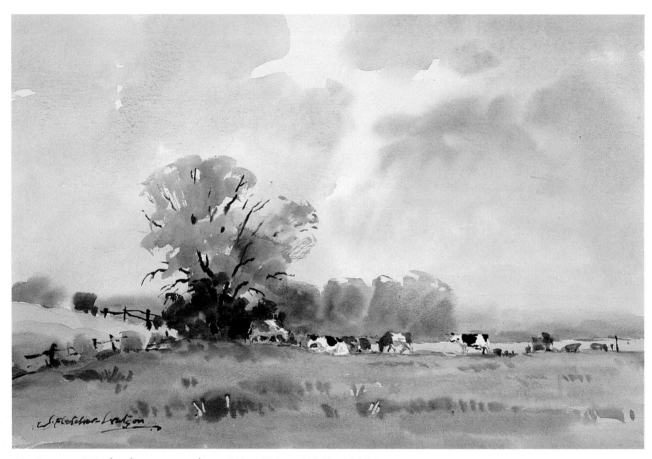

80 *Cows on Windrush water meadows.* 318 x 476mm (12 ½ x 18 ¾in)

Figure 80, *Cows on Windrush water meadows*, shows a picture with rough foreground grass and trees which makes a very pleasing subject, especially with an interesting sky. Cows are lovely animals to have in a country landscape. They are very angular beasts, as **Figure 81** illustrates. To help you in drawing a cow, first draw a wedge-shaped rectangle (**A**), then simply add the head, legs and tail (**B**) and you arrive at the basic shape. I rather like painting the breed shown in this painting which has brown or black markings on white.

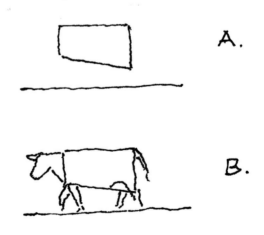

81a Sketching cattle, stage one 81b Sketching cattle, stage two

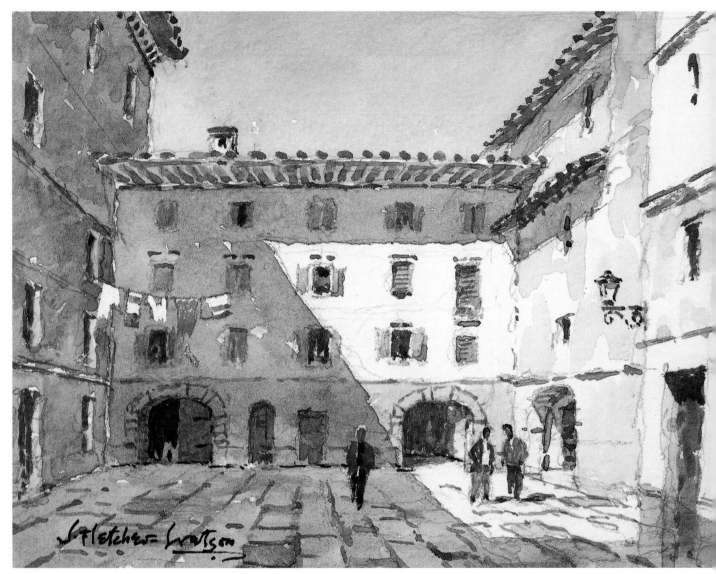

82 *Small courtyard, Florence.* 127 x 165mm (5 x 6 ½in)

Walking down a narrow street in Florence I turned through an arch and discovered the intriguing little courtyard shown in **Figure 82**, *Small courtyard, Florence*. The figures were helpful in giving life and scale to the scene but what really made it was the washing hanging out. There must be a wonderful understanding in Italy that you are allowed to use your neighbour's window for your washing line!

In this very small picture I left the washing till last and then put it in using white paint. It certainly gave a nice domestic touch, standing out from the rather large dark shadow which falls across the left-hand side.

Figure 83 was done as a demonstration for a group of painters. It shows what delightful subjects gardens can be, especially when there is an architectural feature playing a prominent part.

The brick wall had turned a lovely mellow colour with age, and the wrought-iron gate and piers with stone finials made a splendid focal point. The tree groups behind the wall formed a beautiful backdrop of lovely autumnal colours. The copper beech to the left of centre greatly enriched the general colour scheme.

I was using a Saunders-Waterford paper 250lb NOT surface. The order of painting was as follows.

1) The cloudy sky was washed in with Cobalt Blue and a little Burnt Umber added for the areas of grey cloud. I carried this wash over all the trees, down to the wall and into the gate area and allowed it to dry completely.

2) I then felt I wanted to get the brick wall painted, so that I could gauge the tonal strength of the tree background against it which threw it into the sunlight. So I mixed Burnt Sienna with a touch of Cobalt Blue and applied it to all of the wall areas. When dry, I went over

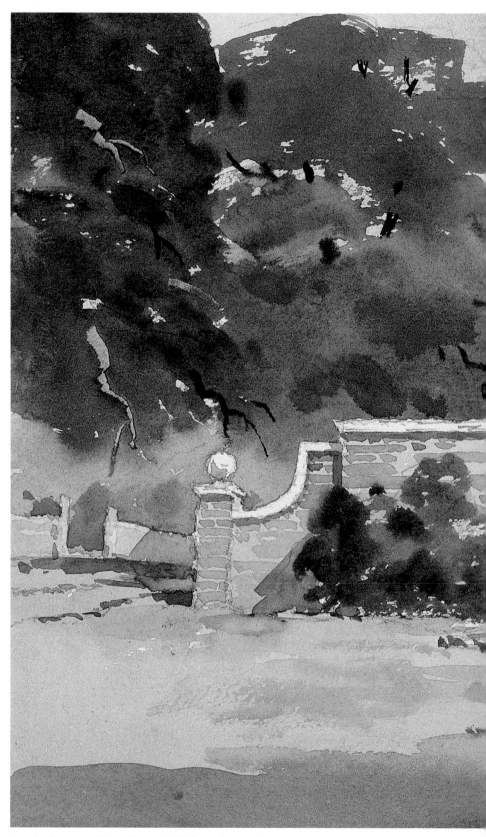

83 *Architectural detail in a Suffolk garden.* 248 x 368mm (9 ¾ x 14 ½in)

120

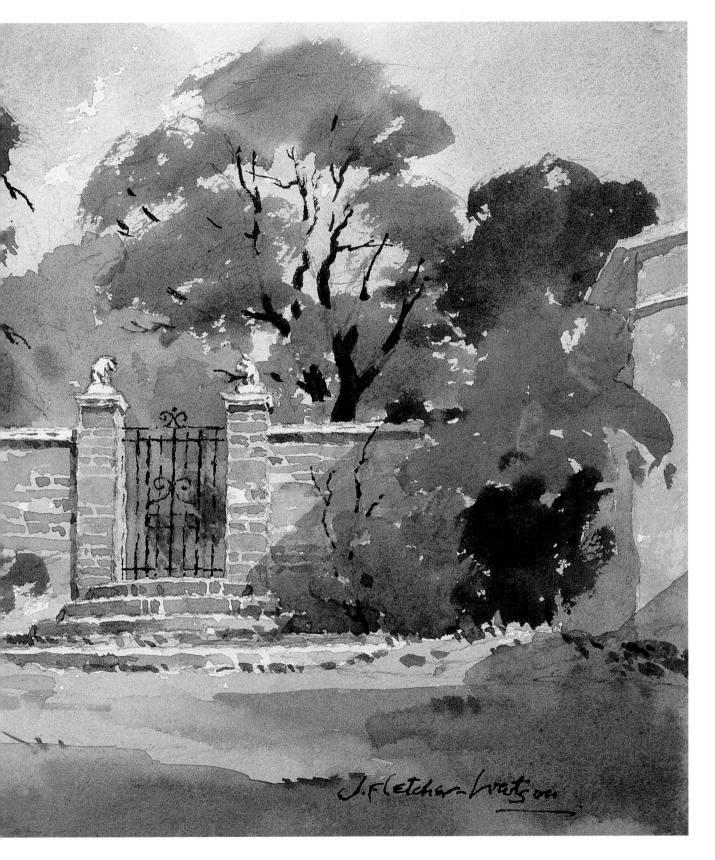

J. Fletcher-Watson

the walls with a second coat of a darker hue of the same mixture, indicating the brick jointing and the texture. The curved steps were also painted using some Burnt Umber added to the brick mixture, as they were a slightly darker brick colour.

3) I then moved on to the mown grass area of the foreground using Raw Sienna and not too much Winsor Blue. This wash completed, I left it to dry and laid the shadows on much later. By this stage I had eliminated all the white paper areas and could safely decide how dark a tone to make the trees in the background in relation to the rest of the picture, a very important matter.

The central grey tree area in the distance was dropped in after slightly damping the paper with clear water to give a distant blurred effect

to these trees. I mixed Cobalt Blue and Light Red for this. Next I used Cobalt Blue and Raw Umber for the shapely tree to the right of centre and sketched in the trunk and branches with a small brush with a Burnt Umber and French Ultramarine mixture. Then the copper beech was painted to the left of centre using Cadmium Yellow, Winsor Blue and Indian Red, giving a dark reddish-green colour. Finally the left-hand tree was put in with Cadmium Yellow, Winsor Blue and Burnt Umber, making sure the result was a dark green. All these tree mixtures were painted quickly with a No. 8 brush and were allowed to run into each other slightly.

4) The distant wall on the left was next dealt with using Cobalt Blue and Light Red, and then I was ready to

paint the various shrubs against the wall. The colour mixtures were mainly Raw Sienna and French Ultramarine, but for the very dark places I dropped in Payne's Gray to give real strength and punch.

5) The foreground shadows were washed across the grass with the same original mixture of Raw Sienna and Winsor Blue, adding a little Burnt Umber. The shadows were cast by trees just out of the picture to the right.

6) Finally the slanting shadows on the brick wall cast by the shrubs (which bring the whole picture to life) were painted with a stronger mix of the original brick colour along with the shadow lines under the stone copings. The iron gate was drawn in with a black pen using an Edding 1800 with a 0.7 nib, which was ideal for the job.

Figure 84 is an example of the importance of technique. It is loosely painted, drawn mainly with the brush and hardly any pencilwork. This picture also demonstrates the skills used for water reflections, boats and figures. Thus it has gained in

quality and impressionism, and the loose treatment of the architectural detail gives a nice feel to the work.

The water reflections of boats and buildings are quite dark in tone, and this is a point you should watch out for.

Several figures are necessary in most town subjects as they give the required life and scale to the buildings. There are good reasons therefore for studying and improving your figure drawing, especially in relation to moving figures.

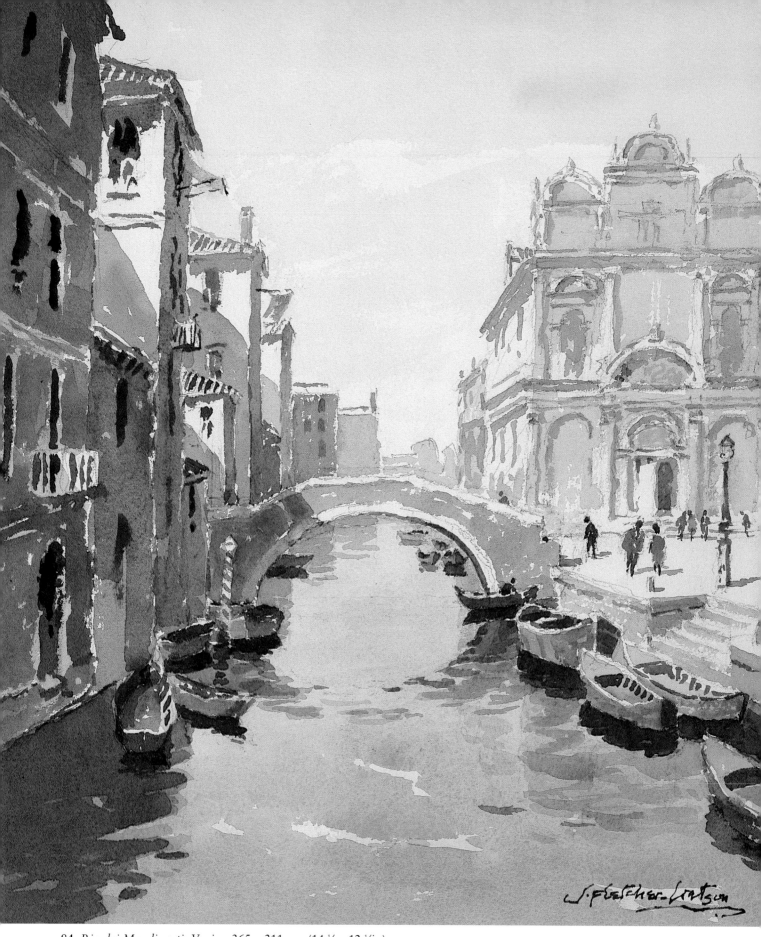

84 *Rio dei Mendicanti, Venice.* 365 x 311mm (14 ¼ x 12 ¼in)

Florence abounds in attractive little side streets and the one seen in **Figure 85**, *Side street, Florence*, led into a small square in which I could sit getting this excellent view. I took some small liberties with certain details to enhance the overall effect of the picture.

The sunblind on the left was not actually there. Instead there was a café with a big umbrella and chairs and tables. However, I decided to include a sunblind because I felt it made a better picture. The big tower above the white house was in actual fact further to the left and almost merged with the foreground houses. Placing it in isolation like this improved the composition. The flag mast, sticking out on the right-hand building, was there but without a flag. I decided to add a dull red flag, blowing lightly in the breeze, which gave the picture a useful touch of colour as well as a sense of movement. Finally, the white house in the centre with green shutters was in reality a strong orange colour, which did not suit my preferred colour scheme so this, too, was changed accordingly.

These are examples of quite legitimate artist's licence, but I do not often alter a scene as much as this. I only mention it to help you with your own painting work in towns.

85 *Side street, Florence.* 343 x 317mm (13 ¼ x 12 ¼in)

Remember that Turner was noted for altering views to suit his mood!

The picture is an excellent example of street perspective showing buildings getting smaller in the distance and the slanting of lines of footpaths, roof eaves, and windows, which all help to convey the depth of the subject. Moving figures help enormously, becoming smaller as they get further away and giving life and colour. The cloud shadow over the tower also gives a sense of recession.

TIPS AND TECHNIQUES

• Look for special details which might give an otherwise ordinary scene a magic quality

• It is very useful to have had experience of life drawing when incorporating figures in any composition. You can also practise by keeping a sketchbook for making quick studies of people

• Plan carefully how you want to incorporate figures into a picture and don't be afraid to embellish or alter the balance of figures that you actually observe to improve the effect of the composition

• Be careful to keep the perspective in the graduated sizes of figures as you move into the picture

• Within reason, you can take liberties with certain details to enhance the overall effect of a picture

CONCLUSION

This book has covered a wide range of landscape subjects and I hope I have managed to be of help to many painters. I have included various types of architecture as well as a good mixture of pure landscapes such as farmland with trees, hedges, rivers, mountains and lakes. When you have mastered the techniques required for the individual features, you can begin to paint in an impressionistic manner, so that your pictures take on a magical, even mysterious, quality that the camera cannot capture.

This is the real secret of watercolour landscape painting. The key is to make a harmonious whole of your picture, subduing some areas and bringing others into prominence. It is just as important to know when to make small adjustments to the general pattern of light and shade where necessary. You will then have the confidence to produce watercolours of real quality.

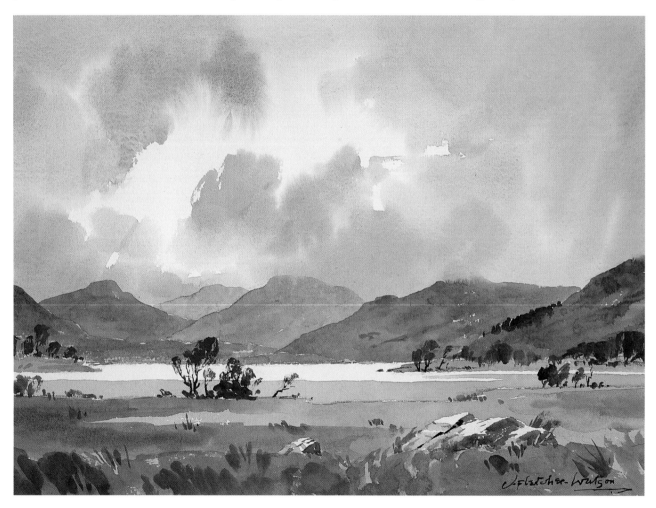